Thinking in the Photographic Idiom

Thinking in the Photographic Idiom

A Book of Perceptual Exercises

Marc B. Levey

James Lloyd

Prentice-Hall, Inc., *Englewood Cliffs, New Jersey 07632*

Library of Congress Cataloging in Publication Data

LEVEY, MARC B.
 Thinking in the photographic idiom.

 Bibliography: p.
 1. Photography, Artistic. 2. Photography, Artistic—
Problems, exercises, etc. I. Lloyd, James. II. Title.
TR642.L48 1984 770'.1'9 83–17838
ISBN 0-13-917955-0

Editorial/production supervision
 and interior design by Joan L. Stone
Manufacturing buyer: Harry P. Baisley
Cover design by Judith Winthrop
Cover photograph by Marc Levey

© 1984 by Prentice-Hall, Inc.
Englewood Cliffs, New Jersey 07632

Printed in the United States of America

10 9 8 7 6 5 4 3 2 1

ISBN 0-13-917955-0

PRENTICE-HALL INTERNATIONAL, INC., *London*
PRENTICE-HALL OF AUSTRALIA PTY. LIMITED, *Sydney*
EDITORA PRENTICE-HALL DO BRASIL, LTDA., *Rio de Janeiro*
PRENTICE-HALL CANADA INC., *Toronto*
PRENTICE-HALL OF INDIA PRIVATE LIMITED, *New Delhi*
PRENTICE-HALL OF JAPAN, INC., *Tokyo*
PRENTICE-HALL OF SOUTHEAST ASIA PTE. LTD., *Singapore*
WHITEHALL BOOKS LIMITED, *Wellington, New Zealand*

Contents

v

Part Three

thirty-six
Self-Evaluation and Critique—124

Preface

A problem confronting all artists is learning to conceptualize within the limitations, idiosyncrasies, and possibilities offered by their chosen form. Photography poses unique problems, for it, more than any other art form, relies on sophisticated technical apparatus to effect the artist's conception. It is precisely because photography demands a particular way of seeing that we offer you this book. We think it is fair to say that to succeed as a photographer, one must begin by thinking in the photographic idiom.

We agree with those who argue that visual acuity is a *skill* that cannot be taught, but only to the extent that it cannot be taught through conventional pedagogy. This book is designed to provide a learning environment that is experience-based. As such, it requires the reader to carefully analyze the results of the experiences generated by the exercises in this book and to make appropriate behavioral changes. This volume can be a catalyst to an understanding of

1. The expressive potential of the medium
2. The potential and limits of your own vision
3. How meaning is derived from visual imagery
4. How the photographer can influence the viewer's perception of reality
5. How photographic vision can be sharpened

This book contains a large number of exercises divided into 36 modules, each addressing a specific issue in the art of seeing. Although we feel the modules are arranged in a logical sequence, do not feel constrained by any particular sequence of learning. Since each module is self-contained, you may learn efficiently in any order.

We admit to our biases, so feel free to disagree with us. There are no pat formulas for heightening visual awareness (either with or without a camera), and because of this you will find quite a few open-ended questions and problems for which we suggest no specific answers. Answers, we think, are to be found through an examination of your experiences as you work through these exercise sets. This is not a book of answers; it is a book of questions leading to more questions and, we trust, to a few answers. At the

end of the book we have listed supplementary readings addressing the issues covered in the various modules. They may give you alternate ways of approaching the material we present.

Picture-taking exercises predominate, but we include non-picture-taking exercises, experiences, and projects as well. We reasoned that it is imperative to heighten sensory awareness of the world around us without a camera so as to take full advantage of the awesome potential that photographic vision offers artists and/or communicators as we put the camera to our eye. You will probably find, as we have, that this process of seeing is interactive: Honing your conscious perception of the physical and symbolic world around you should also sharpen your photographic seeing. In turn, acute viewfinder imaging can lead to a fuller awareness of color, form, line, texture, and so on in our everyday lives. Dorothea Lange summed it up nicely when she said, "The camera is the instrument that allows us to see without a camera."

Seeing is complex and multifaceted and needs to be addressed in many different ways if it is to be understood with any sophistication. For this reason, we have divided the book into three parts.

Modules 1–12 discuss the psychology of visual perception, the development of skill in visual observation, and sensitivity to human qualities as they pertain to photography. Modules 13–21 introduce you to the work of notable photographers both past and present. Each photographer offers you a unique way of seeing. They have used photography to achieve equally legitimate but nevertheless mostly different ends. Modules 22–36 explore a series of visual modifiers: color, exposure, and the illusion of depth, to name a few. Finally, we offer you some guidelines on photo presentation and display, along with what we believe is a valid self-evaluation mechanism.

It is our hope that this volume forms the basis of continued exploration of alternative ways of seeing and imaging.

The Psychology of Visual Perception

1

How we organize visual information is a complex and, to some, little-understood matter. In the early twentieth century, people began to make serious attempts to understand this phenomenon. Pioneers such as Max Weitheimer evolved a systematic approach to the study of visual perception. A major portion of his work is now contained in a body of research and practice known as Gestalt psychology.

Gestalists assert that the whole is somehow different from the sum of the parts. They point out that humans either see selectively, concentrating on one visual element out of many, or see uniformly, perceiving all visual elements interacting as a unified whole. For them, unified seeing *is* Gestalt. Individual visual elements are less important than the unifying theme or agent that ties them together.

Figure-Ground

It is important, we think, that photographers understand how to organize visual information so that they may clarify their own vision and effectively communicate ideas to an audience. Central to the Gestalt point of view is the concept of figure-ground. By no means unique to visual art, figure-ground concerns itself with our constant sensory filtration of incoming information: We make judgments about what seems to be important information and what is not. For artists and photographers, figure-ground means subject-background or positive-negative space relationships; for au-diophiles it is the signal-noise ratio.

The point to remember is that when figure and ground are similar, perception is difficult. In photography, low-contrast, flatly lit scenes are good examples of this. In these instances, how can we determine figure (meaningful content) from ground (background or support)? When we look at a photograph and are hard pressed to determine what it is about, it is likely the photographer did not organize the visual information with sufficient clarity to set up a meaningful figure-ground relationship.

The viewer's eye tends to wander about such photographs more or less randomly. With nothing to hold the viewer's attention or direct his vision, he will most likely lose interest and leave the image completely.

In the exercises that follow, you will have an opportunity to experiment with a number of concepts and techniques concerning the organization and perception of visual information as it relates to photographic communication. We call these concepts *visual modifiers*, and they relate to the construction of a unified visual message.

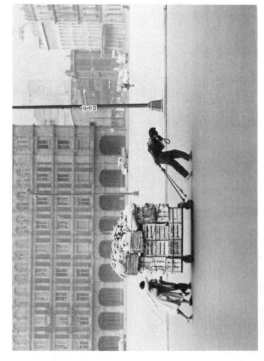

Gerald Lang

A clearly defined figure-ground relationship.

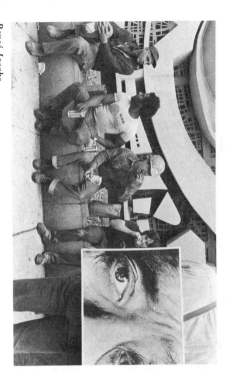

Reneé Jacobs

Figure and ground are a matter of individual perception in this photograph.

Jennifer Anne Tucker

What do you see as figure? Ground?

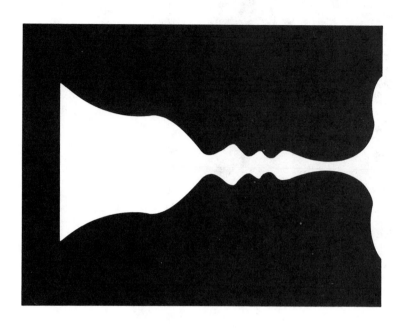

exercises

1. The drawing to the right is a classic example of the figure-ground phenomenon. What do you see first? Can you discern a different figure-ground relationship? What do you think most people see first? Why?

2. Select a dozen or more objects. With your eyes closed run your fingertips over them. Identify as many different textures as possible.

3. Examine a number of familiar commercial symbols, such as the Chrysler Corporation star and McDonald's golden arches. Is there a clear figure-ground relationship? Why?

4. List at least six visual modifiers designed to enhance the figure-ground relationship.

5. Without a camera, observe at least six different scenes. Determine what interests you: What is the content (figure) and what is the background (ground)? How can you help your viewers see this relationship in the photographs you take of these scenes?

The Psychology
of Visual Perception

II

As photographers, many of us find it difficult to see subjects because we seldom attempt any sort of visual organization prior to picture taking. The result—confusing composition, ill-defined subject matter, and general visual disorganization. Learning more about how we organize visual elements as we look through the viewfinder is essential if we hope to communicate through our images.

Gestalt psychologists have offered a set of laws they contend govern how we organize visual symbols. We believe three of the laws have particular application to photographic seeing. These three laws—*similarity*, *proximity*, and *closure*—can explain why certain visual elements in a photograph seem to relate to one another naturally while others do not. Further, these laws can help us determine how much information we need in order to draw conclusions from what we see. Although they can work independently, more often than not they are seen in combination in a photographic image. They help viewers determine what is subject (figure) and what is background (ground). Let's examine each of these laws in the context of photography.

Charles Puckey Jr.

Similarity and proximity tie this image together.

The Law of Similarity

The law of similarity states that objects in a photograph similar in size, shape, color, tone, mass, or vector will generally be perceived as belonging together. The law of similarity extends beyond the physical realm. Ideas or feelings seen in a similar pattern or fashion are examples of symbolic similarity. Physical or symbolic repetition creates energy, and our attention is drawn to the theme by the repeated rhythm. This repetition, which we call *stylized redundancy*, has proved to be a highly effective communication device. Whether the repetition is physical or symbolic, most observers will see and feel the correctness of grouping elements together if the law of similarity is employed with skill.

The Law of Proximity

According to this law, the closer visual elements are grouped in a photograph the more likely they will be perceived as a whole—that is, as a unified element. As with similarity, proximity enhances visual organization. And not unlike similarity, proximity can dictate certain associations to the viewer. For example, an image of a child's hand near an open flame leads the viewer to draw an all but inexorable conclusion. But if the child's hand were far from the flame, one might be hard pressed to make the association.

The Law of Closure

This law states that forms, shapes, and lines are generally seen as complete rather than incomplete. Physical closure is an important concept for photographers. Many times we cannot or do not want to present a complete physical form. Think of the sun as it sets. We need not show the complete sphere, for viewers will complete it. Remember, however, that we must offer viewers sufficient visual information for closure to take place. How much is necessary depends on how familiar the audience is with the subject matter. Obviously, unfamiliar subjects require more complete visual information than familiar ones.

So far we have concerned ourselves with physical closure. At least as important, and perhaps more so, is psychological closure. Psychological closure involves making value judgments about visual information. Providing viewers with familiar visual symbols can assist closure. Skillful manipulation of visual information allows us to imply meaning without being overly obvious. Thus, a missile on its launch pad may be perceived not as a physical thing but as a symbol of power, waste, achievement, or any number of other meanings. How you portray it can lead the viewer to draw certain conclusions. There is no certainty that what the viewer derives from a photograph will be at all the same as your understanding of it. As with physical closure, viewers make conclusions about the meaning even if all the information is not present. There need be only enough to foster symbolic association.

These three laws incorporate the traditional thinking about perception. We believe they serve merely as a convenient beginning point in the analysis of visual perception. They are not sacrosanct! That most of us organize what we see according to the laws of Gestalt doesn't mean we must adhere strictly to them when we organize our photographs. In fact, some of the most striking and memorable photographs run counter to all rules of composition, design, and visual organization.

Gerald Lang

One need not present physically complete objects—the viewers will complete them in their minds.

exercises

1. Find and photograph three scenes illustrating the Gestalt laws of visual organization discussed here.

2. Photograph a subject using the concept of psychological closure. Test your perception on a number of viewers.

3. Find instances where the laws do not apply. Photograph scenes that work best pictorially when violating one or more of the laws. Explain why they work in such a way.

4. Examine a number of photographs having strong graphic composition—that is, photographs having organizational patterns that are readily observable.

Kathleen Langston

What do you conclude about this woman?

a. Does the organizational pattern help you understand the image? If so, how?

b. How does the organizational pattern influence the way you see the image?

c. Is the organizational pattern harmonious with the residual message?

d. Finally, what organizational pattern or constructs do you seem to favor?

A Method for Deriving
Meaning from Photographs:
The Residual Message

Photographs are potent communicators of information, ideas, feelings, and points of view, whether this is intended or not. Billions of dollars are spent annually on advertising photography. Why? Because photographs used in advertising can, if done effectively, manipulate our perceptions to the extent that they create a need where none previously existed. This visual sleight-of-hand comes about when the product is tied to an idea. If the bond between product and idea is forceful enough, the product acquires a symbolic meaning having little or nothing to do with its function.

A case in point is the Pepsi-Coke ad battle of the 1970s. Both ad campaigns depicted bikini-clad, golden-haired girls and tan, well-muscled studs frolicking on the California beach. These ads had the young sun gods and goddesses conspicuously consuming huge quantities of the product. Were we being sold cola? Probably not. At least we didn't buy just cola. We bought sun, fun, youth, and, somewhat more subtly, liberal sex. That these campaigns succeeded is apparent to anyone for whom "the Pepsi generation" has any meaning.

Does this example have anything to do with how meaning is projected by photographic images? Many people who study the process of communication postulate that meaning is derived not from any specific symbol in an image but rather from *the residual message*—the pervasive impression that all of the symbols, taken as a whole, project.

Can you identify an overall impression that you are left with after viewing each of these images?

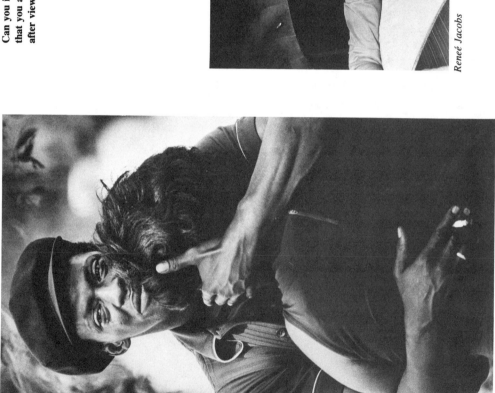

Reneé Jacobs

Jim Jennings

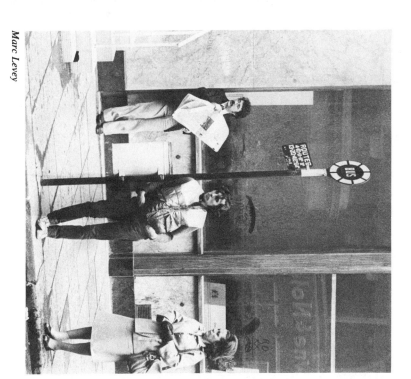

Marc Levey

Jennifer Anne Tucker

The residual message can have a profound influence on social and political attitudes. For example, a growing number of students of public opinion have concluded that one photograph of the Vietnam era—that of a Vietnamese general executing a bound and tied youth in the street—did more to turn the American public against the war than did television coverage and antiwar rallies, books, and editorials. Why? Because the horror and futility of war, and in particular this war, were so graphic that they assaulted our senses. There was no way one could ignore the residual message implicit in this image.

It took a seasoned photojournalist and an astute editor to recognize the potential impact of this particular photograph. But even they grossly underestimated its effect. For us, the residual message projected by this photograph is evidence that images can and do have a profound influence on our visual perception.

If we first determine intent—what feeling, attitude, or reaction we desire—the other decisions of technique, composition, exposure, and so forth become self-evident. This argument stems from the following simple assumption: All great photographs say *something*. To a great extent, control can be exercised over what is said and to whom. This is a choice all photographers have but too few exercise. If we opt for a measure of control over what we communicate, we need to know what we wish to say. Assuming the residual message is the essential communication of any photograph, it may well be the place for us to begin. In any event, it is probably the only thing our audience will take with them.

exercises

1. Choose several magazine ads. Study them and ask yourself
 a. What is the product?
 b. What is the residual message?
 c. Who is the intended audience?
 d. Does the residual message enhance the appeal of the product? If so, how?
 e. Why did the advertiser choose this particular message?
 f. Does the use of color, composition, setting, perspective, and layout support or detract from the residual message? How?
 g. What is the significance of the magazine chosen for this ad?
 h. If you were doing this ad, what would you do differently? Why?
 i. Discuss your responses to the above questions with friends or classmates. Do they agree with your assessment?

2. Choose a product, real or imaginary, and then
 a. Define an audience or market for it.
 b. Choose which publication you would advertise in.
 c. State the intended residual message.
 d. Specify a design—props, location, models, and so on—and write a detailed layout of the illustration (story board).
 e. Generate a number of photographic interpretations of your design and solicit critiques of each.
 f. Select the image that seems to accomplish your goal.

3. Choose an idea or social problem and repeat the steps in exercise 2.

4. Select any ten of your photographs, and for each record what you feel is the residual message. Ask several of your friends or classmates to view your photographs and list their instinctive reaction to each. Compare the two lists and reexamine the photographs. Do others see things that you don't? How do you account for this?

Becoming an Acute Observer

four

1

One must have several skills in order to become a perceptive photographer. None is more important than the ability to observe acutely. As a skill, critical observation is not easy to acquire. Most of our lives we simply orient ourselves to our surroundings without making any conscious attempt to see and understand physical relationships. On another level, we seem to perceive and understand human behavior only when it affects us directly. Even then, we understand only what we need to in order to solve the problem at hand. So, for many of us observation and perception are functional, subjective, and intermittent.

When we turn our attention to photography, our immature observational and perceptual skills fail us. We expect the camera to "see" for us; when it doesn't, we are frustrated sometimes to the point of giving up photography completely. To reduce potential frustration, remember that *cameras do not think, judge, evaluate, or interpret.*

We can adjust to camera-vision idiosyncrasies relatively quickly and begin producing technically correct pictures. For some, this is enough. However, other photographers demand more than technically correct images. They wish to express themselves through their work. Photographs satisfying this need come about only when we understand what we see, and understand it within the context of the medium—in other words, when we see the world photographically.

How do we learn to see photographically? Above all else, by *becoming more discerning and sophisticated observers.* And we can become more perceptive observers only through direct experience, and a lot of it. Therefore, a major thrust of this book is to provide experiences that stretch and challenge your observational ability. We hope these exercises and evaluative tools will demonstrate the expressive possibilities open to you through your photographic image-making.

exercises

These exercises are an appetizer, a first course in conditioning your thinking and seeing in a new way. Even though they are a potpourri, they do have a common purpose—to test and develop your observational power.

1. *Observing People*

 a. In a crowded elevator, observe how people act.
 (1) How do they stand?
 (2) What do they look at?
 (3) How do they respond to being touched?
 (4) What are the norms for behavior in this situation?
 (5) Why do you think they act as they do?
 (6) How is space used to communicate?

 b. Observe people on a bus, plane, or subway.
 (1) How do they interact with the other passengers?
 (2) How do they "protect" their personal space?
 (3) Do you think their behavior is culturally determined?
 (4) How would you deal with this situation on a photo assignment?

 c. Solicit the help of two of your friends who don't know each other. Ask them to stand about ten feet apart and begin chatting. As they talk, instruct them to move closer and closer together until they begin to feel uncomfortable. Observe their behavior at various distances. At what distance did you note discomfort? How did you know they were uncomfortable? What relationship is there between space and human behavior in general?

2. Find several willing participants, both adults and children. Ask them to relax. Explain that you wish to take their photograph in order to check your camera out. Then, beginning at ten feet or so, gradually move toward them with the camera until you are only about two feet away. Record their reactions. While you are moving, take several photographs. Examine them for photo evidence of your observations. How did they behave as you moved closer? Did the adults react differently than the children? If so, how do you account for this?

3. Find something around the house that you have recently painted—a wall, a piece of furniture, a bike. From the store where your purchased the paint get a number of paint samples—one that matches the color of the object exactly and others of slightly different tints and shades. Try to get ten to twenty different samples. Next, study the object you painted, fixing the color in your mind. Then, with the painted object out of sight, study the samples and choose the exact color you used to paint it. Take as much time as you need. Record the sample you selected.

Finally, ask several others to repeat the experiment. Did you choose the correct sample? Did everyone else? What does this experiment tell you about your ability to observe color or define it precisely? Is color subjective or objective? Do the same problems exist when we try to define the qualities of light?

4. The object of this exercise is to find out how well you observe differences in naturally occurring events over time. First choose an outdoor scene rich in detail. Then, using the following chart as a guide, observe the scene at various times of the day. Fill in the chart on the next page.

Observation Chart

Time	Subject	Color	Light direction	Intensity	Contrast	Shadow Quality	Comments

5. As an exercise in observation, formulate a mental plan for photographing a sporting event. (You may wish to attend a sporting event first and take careful notes.) Anticipate potential shooting angles, lighting conditions, obstructions, and so forth. Study the sport to determine where and when the action will likely occur. Plan for human-interest photographs by observing crowd behavior. Make a checklist that includes the following:

 a. Equipment choice

 b. Film type

 c. Advantages and disadvantages of various perspectives

 d. Potential problems and solutions

6. First thing in the morning, go into the bathroom and take note of as many different photographic subjects as you can find. Keep practicing until you can generate at least 25 separate subjects. You can follow up your observations with a photo record if you choose.

7. Describe a typical outdoor scene. List at least 20 different adjectives or phrases that define it. Be specific. You may describe the entire scene, parts of it, or both.

8. In terms of specific and observable behaviors and/or physical features only, define and illustrate with a photograph each of the following:

 a. A beautiful woman

 b. A handsome man

 c. An adorable child

 d. A depressing sight

 e. An exciting event

9. List ten things you see that you think will look different in a photograph taken by a completely automatic camera. Explain why.

10. Go downtown and make a list of 30 or more red things. Allow yourself only ten minutes. Repeat the exercise with several different colors.

Reneé Jacobs

Observing people in typical situations can lead to surprising results.

11. In this exercise, try thinking and seeing symbolically as well as literally. Give yourself ten minutes and list

 a. 20 dark things and 20 light things

 b. 20 small things and 20 large things

 c. 20 crooked things and 20 straight things

Choose several of the subjects from each list and photograph them. Photographs do not always reflect what we conceptualize in our mind's eye. What happened when you attempted to translate your mental pictures into photographic images?

12. Divide your note pad into two sections, one headed *positive* or *happy* and one *negative* or *sad*. Observe at least 20 persons and put each into a category. Note your reasons for making these judgments. Try this exercise again, only this time photograph the people you put into each category. Do your photographs capture the qualities that led you to categorize the people as either positive or negative? What did you key on as you looked through the viewfinder? Was it the same kind of "vision" as simple nonphotographic seeing? In what ways does "viewfinder seeing" limit or expand your perception of your subject matter?

five

Becoming an Acute Observer
II

Meaningful photographs don't just happen; they result from a blend of technical competence, sensitivity to the subject, and in some instances luck. To trust to technical competence or luck, however, is to beg the fundamental issue—that photography is a special and in some ways unique vehicle through which we can share something of our world with others. By attempting to understand the values imparted by a subject, we have a better chance to communicate effectively. The problem is that most of us see in gross generalities, attaching generic or categorical labels to our subjects. Seeing in these terms results in photographic images that say nothing about the special qualities of the subject. To go beyond seeing in these gross terms, we must learn to develop and refine our observational skills.

Charles Puckey Jr.

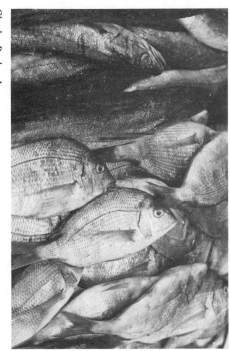

Gerald Lang

Fascinating renditions of familiar objects.

The following exercise will not by itself magically transform you into a keen observer of every visual nuance. It's not intended to. The goal is simply to challenge your senses to "discover" with more than just your eyes.

exercise

This exercise consists of two activities.

1. Choose an unfamiliar outdoor location. Select a starting point and take thirty steps from that point. Mark the spot you arrived at and walk off a four-foot square. Stake it out if possible. Choose several perspectives, walking around and within the square. Concentrate on the square, being aware that your very presence can change the nature of the space.

 a. Write down your first impressions.

 b. List as many photographic subjects or possibilities as you can see. You can divide this list into subjects you see while observing the square as a total environment and those you find as you examine detail within the square. If you can come up with a dozen or so subjects, you've done well.

 c. From your list select

 (1) A subject that represents the entire environment of the square

 (2) A subject that can represent a particularly interesting feature within the square

 d. Now, photograph the two subjects you've selected and examine the resulting prints or transparencies. Do they convey the impression you intended? If not, can you determine why? Return to the same location and repeat the exercise, if necessary.

2.

 a. Select a subject that is especially interesting to you—a flower, a plant, a piece of pottery. Sit near the subject so that you can concentrate on parts of it but still see all of it at one glance. Observe the relationship various parts have to one another. Examine detail closely. Experience texture by running your fingers over and around the surface of the subject. Do this first with your eyes open, then closed. Do you notice any difference in sensation? Smell the subject. Is there any aroma or odor?

 b. Move in until you are only about 12 inches from the subject. Now, reexamine it in detail. As in the first part of this exercise, take time to really appreciate the object. Did you discover anything that surprised you? Is there any one impression that stands out? If you were to photograph it now, would your approach to the subject be any different than before you "discovered" the subject? Can you state why? Try to record the experience on film.

Marc Levey

A bulb is a bulb. Or is it?

The Part as the Whole:
Sensitizing the Eye
to Detail

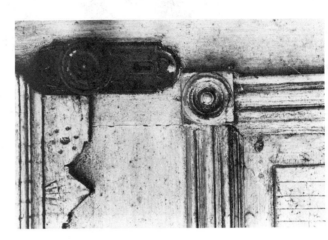

Marc Levey

The rich detail and design projected in the image help us determine the character of the unseen portions of the door.

Most scenes we photograph contain abundant detail often overlooked by the undiscerning observer. Photographers with a sensitive eye can record memorable images by selecting detail, rather than the whole, to represent their impression of a scene. In some scenes detail may be the only important pictorial content; subtle nuances of color, texture, and form found in detail are often visually compelling. Commonplace subjects often contain one or more details that go unnoticed when viewed within the context of the total picture. Yet by isolating and highlighting these details we can turn an otherwise dull image into one that is visually exciting. Detail is especially compelling in architecture and travel photography, for it can highlight unique qualities that are lost in photographs of an entire structure or panorama.

Abstracting detail take patience and a keen eye. You may find yourself moving close up to where you've never ventured before. The following exercise will help you become aware of the abundant detail all around you.

exercise

1. Choose three landscape and three architectural subjects. Spend some time examining the features of each. Try to discover detail that is especially interesting. Plan your photograph so as to make detail the center of interest.

2. Visually describe a structure by first photographing it in its entirety. Then photograph as many of its structural details as needed to give the viewer a full appreciation of it. Emphasize texture, color, rhythm, or function.

3. Answer the following questions about your experience:

a. Did you have difficulty seeing interesting detail? How do you explain this?

b. How did the discovery of interesting detail add to your understanding of the scene? How do photographic images of these details help the viewer appreciate the subject?

c. Did the experience change the way you see? If so, how?

d. How do you know when details are more important than the whole?

e. What new techniques, if any, did you learn?

Marc Levey

This image demonstrates how the part can represent the whole.

Visual Editing

Jim Jennings

The photographer selectively edited this image in the viewfinder.

Most beginning photographers repeat the same mistake: They simply include too much in a picture. There is something about moving in close to visually edit a scene that makes many photographers stand back. Perhaps they feel uncomfortable or are more used to maintaining a safe distance from the subject. Images resulting from this standoff approach often lack a sense of immediacy between photographer and subject. Even if technically perfect, they may lack vitality, the result being a clinical rendition of the subject. Further, such photographs lack a visual focal point—a central point of interest to arrest the viewer—and so the viewer's eye tends to wander from place to place, never fixing on content.

There is an old proverb: less is more. Applying it as a practical matter, photographers can help viewers cull meaning from images by limiting the visual choices available to them. How do we do this? By practicing a skill we call *visual editing*. Visual editing is nothing more than including only those elements in an image that support the theme. By eliminating or deemphasizing those elements not essential to the meaning of the image, we can increase the likelihood of something being communicated between photographer and audience.

There are numerous instances when visual editing is not possible or practical—for example, fast-breaking action or grab shots. Fortunately, photographers have any number of opportunities to edit. Here are four such stages:

1. Initially, as we study a potential photographic subject without a camera

2. In the camera viewfinder before we press the shutter release

3. In the darkroom during printing or in the projector as we view slides

4. After printing, as we examine the final result

Jim Jennings

The power of this image is heightened because the photographer tightly cropped the negative in the darkroom.

Many photographers tend to edit only at stages 3 and 4. Although much can be done to improve a photograph after it has been taken, editing before this stage makes more sense. One has more control over subject matter, and is closer in time to the event and so should be more sensitive to it. Also, some materials, particularly transparency films, do not lend themselves readily to later editing.

In summary, too few photographers move in close enough to focus on content. Not enough attention is paid to mental editing prior to physical picture-taking. Practiced and perfected, visual editing can give our images immediacy and vitality as well as mirror our beliefs and values.

exercise

1. *a.* Locate a subject and photograph it as you would normally.

 b. Next, from an 11-by-14-inch piece of stiff cardboard cut out a 4-by-6-inch rectangle if you use a 35mm camera or a 6-by-6-inch square if you use a 2½ square-format camera.

 c. Holding the cardboard about 8 inches from your eyes, view the same scene through the cutout. Pay attention to objects near the edges and corners of the frame. Determine what, if anything, you can eliminate within the frame without affecting the essential quality of what you see and feel. Jot down your impressions of the experience. Rephotograph the scene when you are satisfied you have edited it sufficiently.

 d. Evaluation:

 (1) Was there any difference in the two picture-taking experiences? What?

 (2) Which photograph projects the desired qualities? Why?

 (3) Did you change perspective—that is, move physically closer or farther away? How did this alter the image?

 e. Repeat the exercise with different scenes or subjects.

2. *a.* Mount a favorite lens on your camera. Set the focusing ring to minimum focus and tape it so that that focus cannot be changed. Look for a number of doors that have interesting doorknobs or keyholes. Shoot a series of photographs of these subjects. The taped focusing ring will force you to move in close in order to sharply focus the image.

 b. Shoot at six different portraits with the lens taped as in step A.

 c. Evaluation:

 (1) What did you discover perceptually about moving in close to the image?

 (2) How did you feel about the portrait-shooting sessions? What were your subjects' reactions?

 (3) Was your reaction or understanding of either set of subjects altered? If so, how?

3.

a. From a large piece of cardboard cut out two L-shaped pieces. The L's should have "arms" about 2 inches wide and long enough to frame an 8-by-10-inch print. Choose a number of 8-by-10 prints—they need not be your own. Arrange the cropping L's so that they frame the print. Examine each print, and by sliding one or both L's form smaller and smaller rectangles on the print.

b. *Evaluation:*

(*1*) Of the prints examined, how many were improved by cropping? Were there any that needed little or no cropping?

(*2*) Did you make any new visual discoveries? Are there pictures within pictures?

Learn How to Respond
to the Moment

From the tradition of Henri Cartier-Bresson, Edward Steichen, Andre Kertesz, W. Eugene Smith, and other notable photographers, a style evolved into what we can call the *picture-taker* school of image making. Picture takers, including most of the celebrated photojournalists of our time, would suggest that over-attention to conscious preplanning, design, deliberate technical manipulation and technique becomes a barrier to the involvement of the photographer and subject.

Picture takers would place greater emphasis on the natural relationship of the photographer, as a person, to events unfolding before him or her. This allows the photographer to merely use the camera to freeze these moments of understanding as they unfold. To the picture takers, immediacy and spontaneity are essential. Preoccupation with the tools impedes understanding.

Many of us are so concerned with camera controls, choices of lens and film, and correct exposure and focus that we fail to see *anything* except the most obvious. The photographs that we end up with reflect this insensitivity to and uninvolvement in what is happening. All of us fall victim to it and have the commonplace photographs to prove it.

Charles Puckey Jr.

Street photography requires good instincts and quick responses.

We don't suggest that everyone can become an incisive photographer, but that a shift in photographic priorities might prove cathartic or at least instructive. This exercise is based on a classic technique of street photographers. Work through it and judge for yourself.

exercise

A 20-exposure roll of ASA 400 film is desirable.

1. Choose a setting that includes people and action, such as a sporting event, a shopping center on a Saturday, or children at play.

2. Use a lens with a focal length of 50 mm or less if you have one.

3. Take ten pictures as you ordinarily would—that is, paying close attention to exposure, focus, and correct composition. Try to concentrate on images within about 20 feet of the camera.

4. With the same lens on the camera, choose as small an aperture as possible while still allowing for a shutter speed that is feasible with a hand-held camera. Set your exposure.

5. Prefocus so that the majority of subjects within 20 feet of the camera are in focus.

6. Shoot the remaining ten photographs on the roll concentrating solely on the action before you. The object is to set exposure once, prefocus, and then forget about camera controls. Think of your eyes as the camera lens and attempt to get into the flow of the activity. Don't be afraid to hold the camera at different angles or to change your vantage point. Do whatever you *feel* like doing. It's not important to consider what makes a "good" picture at this point—just react to what you see and feel.

7. Process the film and examine the two sets of images. Answer these questions:

 a. Do you see any differences overall? If so, what are they?

 b. What do they reveal about your sensitivity as a critical observer?

 c. Did technical manipulation of the camera get in the way of seeing? How?

 d. Is the content of each set of images different? How do you account for this?

 e. How did you feel when you were taking the first set of pictures? The second? If different, how and why?

 f. Ask others to examine the two sets. Then ask if they perceived any differences. You might repeat the exercise a number of times in different locations. After a number of attempts, try to determine which style feels right for you—the more deliberate *picture-maker* style or the more free flowing *picture-taker* style.

 g. Ask yourself which technique lends itself for use in various situations. Make a list of situations for each technique.

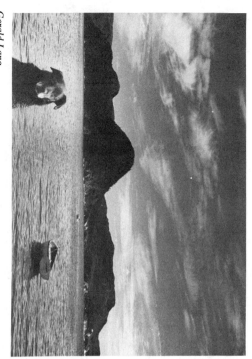

Gerald Lang

When responding to what we see in the viewfinder, we can't always worry about technique.

Learn to See
by Following Your Senses

We live in a world of symbols. Some we take for granted; others we ignore. Still others we must concentrate on consciously in order to understand. Although most symbols we recognize are visual, many others are received by other senses. Total perception does not necessarily depend on the input to a single sense but may result from the stimulation of two or more senses simultaneously. Just as our hearing is often tuned or directed by what we see, our visual sense is influenced by signals received by other senses.

It seems clear, then, that our photographic vision can become more acute when we allow other senses to direct our vision. The key is to be open to all incoming information—in other words, to be totally aware.

The following exercise is meant to demonstrate to you the interrelationship of the senses in the creative process.

exercise

At suppertime, walk into the kitchen, close your eyes, and smell the aromas wafting through the air. Pick out the one or ones that dominate. Can you identify them specifically? What "color" are they? How do they "feel"? Can they be represented by any physical objects? What memories do these aromas bring to mind?

Plan and shoot one or more photographs that capture your sensory experience. You may wish to repeat this exercise in a number of different settings. Try a field of spring wildflowers and an industrial area of the city, for instance.

Kathleen Kissick

How does this image "feel"?

Thinking in the Photographic Idiom:
Suggested by the Work
of Freeman Patterson

Freeman Patterson is a writer, photographer, philosopher, and teacher whose two books, *Photography for the Joy of It* and *Photography and the Art of Seeing*, are examples of what photography books should be. Rather than a collection of words and pictures these books are thoughtful, visual, and narrative works that encourage learning.

The keystone of his philosophy is one we embrace wholeheartedly. Patterson advises us to become aware of what we see, to begin thinking visually, as he puts it. Throughout his work we see demonstrations not only of visual thinking but of *innovative* visual thinking. What is innovative visual thinking? For us, it is not being so concerned with theory, rules, and laws that we become visually inflexible. Conventional visual thinking is predictable, if safe. The images recorded by the conventional thinker are bound to reflect a sameness, and a kind of artistic lockstep having no surprise or sense of wonder left to the viewer. For photographers, this type of thinking can do nothing but stifle innovation and the excitement and joy of discovery.

We concur with Patterson that most photographers are too rule-bound; rules can limit the breadth of our vision. However, we don't

A modification might involve having someone select a few objects of widely differing textures. With your eyes closed, sense the surface texture of each and ask yourself some questions, as in the kitchen exercise.

It is not important to produce a photograph that replicates this sensory experience but to determine how inputs to senses other than sight can be translated into the photographic idiom. If you can see the "color" of what you smell or have a photographic scene pop into your mind, you have succeeded. Be patient! It might take some practice and good concentration, but sensitivity comes in time.

suggest that all rules be dismissed out of hand. Some of the rules governing the physics of photography are, for now, fixed. Photographers whose thinking is flexible take the rules into account but don't allow them to dictate. Rather, they integrate rules into a total pattern of thinking.

How then can we evaluate the usefulness of rules and laws? And how can we innovate? The following provide a framework in which you can answer these questions for yourself. They are designed to help you activate your inner eye, the one held in check by convention. Don't expect dramatic images immediately, for the goal is only to have you practice a new approach to visual thinking.

exercises

Each exercise contains first some basic rules of conventional seeing and then some unconventional approaches. Take several photographs from each approach and answer the evaluation questions. Evaluate each set of photographs before going on to the next exercise.

1. *a. Conventional seeing:* Place the main subject off center at the junction of horizontal and vertical lines, dividing the frame in thirds (the rule of thirds).

 b. Unconventional seeing: Surround the subject with an equal area of space vertically, horizontally, and midway into the field of view.

 c. Evaluation:

 (1) What visual differences do you notice between the two images?

 (2) What mood does central placement add? Can it be combined with other techniques to strengthen an image?

 (3) What problems arise from central subject placement?

 (4) What subjects lend themselves to central placement? Which do not?

Marc Levey

Breaking the rules.

2.

a. *Conventional seeing:* Never compose a photograph in which you place significant content at, or moving toward, the edges or corners of the frame.

b. *Unconventional seeing:* Deliberately compose an image in which you place significant content at the edges or corners of the frame.

c. *Evaluation:*

(1) What viewer reaction will edge or corner placement of subject cause? What did *you* see?

(2) Why did you choose the subject you did for edge or corner placement?

(3) Is compositional harmony always desirable? If not, cite instances where disharmony is preferred.

3.

a. *Conventional seeing:* Fill the frame with content. Don't leave too much static space, such as large expanses of foreground in a landscape.

b. *Unconventional seeing:* Divide the picture format either vertically or horizontally and place content in only half of the space. Leave the other half devoid of content in the traditional sense.

c. *Evaluation:*

(1) Compare the resulting photographs. What impression does each image project? How is each different?

(2) In the unconventional images, is the empty space of any use? Would it be better to crop it out? How can this space be seen as dynamic rather than static?

4.

a. *Conventional seeing:* Carefully and thoughtfully study the scene to be photographed. Focus, compose, expose, and edit deliberately prior to actual picture taking.

b. *Unconventional seeing:* Prefocus the lens and set the exposure. Hold the camera at arm's length and sight down the lens axis much as you would with a firearm.

c. *Evaluation:*

(1) Did you sense any disorientation while photographing at arm's length? Did you have difficulty limiting your view to the viewfinder image? Did you sense any visual freedom?

(2) What do the two sets of images reveal? Which approach is more suited to your personality or style? Did you discover anything about photographic seeing? If so, what?

5. This exercise consists of essentially the same tasks as in exercises 1–4, except that we provide only blank work sheets. Your job will be to define conventional seeing situations and then set up unconventional alternatives to them. Use the evaluation sections of the work sheets to discuss what differences in impact, mood, viewer reaction, and so on would result from each set of images. Shoot a series of photographs to test your hypotheses.

1. *Conventional Seeing*

Unconventional Seeing

Evaluation

Evaluation

2. *Conventional Seeing*

Unconventional Seeing

Evaluation

Evaluation

3. *Conventional Seeing*

Evaluation

Unconventional Seeing

Evaluation

4. *Conventional Seeing*

Evaluation

Unconventional Seeing

Evaluation

Seeing Others

Steven P. Mosch

Historically, photographers have chosen the portrait to express many facets of the human condition. Contrary to what many think, portraiture is not one unified subset of photography, but several.

The Subsets of Portraiture: Some General Observations

Formal

Formal portraits are taken in a controlled environment and are created for a specific purpose. A traditional pose is used.

Marc Levey

Studio portraiture allows us to control all the variables.

1. *Advantages of formal portraiture:* The photographer has virtually total control over lighting, background, pose, dress, and so on. He can create a desired mood through the use of props and special effects.

2. *Disadvantages of formal portraiture:* Much formal portraiture lacks vitality and is indifferently executed. Formal portraits can lack immediacy and spontaneity and at times appear staged and unnatural.

Candid

At the other end of the spectrum is candid portraiture, in which the subject is totally unaware of the camera.

1. *Advantages:* The candid portrait can have a natural, unposed look and feel about it. The photographer is free to explore an unlimited number of subjects and settings, recording moments of time on film. She is also free to comment visually through selective editing in the viewfinder.

2. *Disadvantages:* There is little or no control over the subject, and luck sometimes plays a role. Since photographers must be prepared to act quickly, they need to be highly proficient in visual editing and exposure manipulation. Further, an extensive knowledge of materials is essential.

Informal

Informal portraiture is a mixture of formal and candid. The key feature of informal portraiture is that the subject is a cooperating partner in the effort. In general, the informal portrait takes place in a relaxed nonstudio environment.

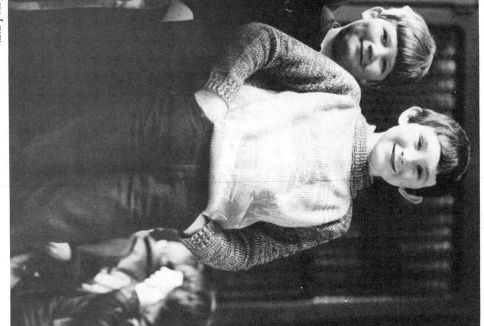

Marc Levey

There is obvious rapport between photographer and subject.

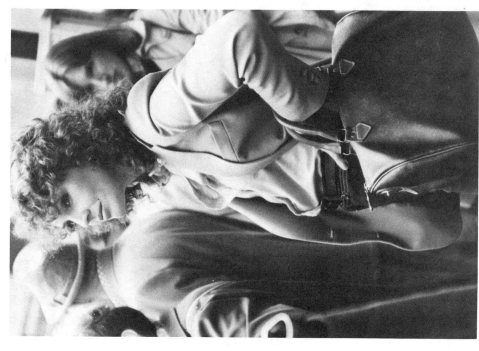

Marc Levey

Caught in an unguarded moment, people are most natural.

1. Advantages: Informal portraiture can be a more natural experience for both the subject and photographer. A nonstudio setting sometimes permits a wider range of creative possibilities. Further, less sophisticated equipment is generally required.

2. Disadvantage: The photographer loses total control over the process.

In both the formal and informal modes of portraiture, both the photographer and the subject share the experience of the portrait shooting. The goals of the shooting can be discussed in advance. In the best of circumstances, the portrait can be a joint, creative experience. At worst, it will reflect only a likeness of an individual—an adorned mug shot.

Candid portraiture is another matter entirely. It is largely a case of shooting from the outside in, and thus the photographer is usually an onlooker peeking at life as it unfolds before him. The images become more of a statement of what the photographer believes and thinks than of the subject's value system or character. That some characteristic of the subject is captured on film is, for many candid photographers, incidental to the real purpose—a statement of the photographer's values.

Relating Something of the Character of the Subject

Conventional portrait theory tends to stress the mechanical aspects of the craft. In our view, however, studying plans and lighting diagrams or constructing elaborate backgrounds do little to make us perceptive observers of human character. It is only when we understand the subject as a unique human being that we can translate onto film the essence of his or her character.

We can portray a portrait subject

1. As the subject wishes to be seen
2. As others define him or her
3. As we, as photographers, see him or her

No matter what vantage point we select, our ability to abstract the essential character of the subject determines the success or failure of our portraiture.

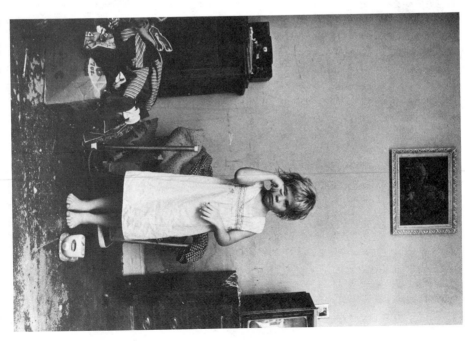

Reneé Jacobs

The little girl is probably aware that her picture is being taken, but is not a cooperating partner.

In subsequent modules you will be asked to study the work of several candid photographers, Eugene Smith and Henri Cartier-Bresson among them. But for now, the 18 exercises that follow will help you gain experience in the diverse nature of portrait photography. Before attempting these exercises, you may wish to study the following lighting examples (provided by the Smith-Victor Corporation). While each of the 19 lighting setups is an example of traditional studio lighting, we feel much can be learned from them. These basic lighting techniques provide different effects through varying light placement, intensity, and quality. The illustrations and text are an excellent place to begin your study of artificial lighting. (You may also find it illuminating to refer to module 29.)

Basic Lighting Techniques*

Lighting need not be one of the most misunderstood and least-known components for successful visual imaging. We hope, through this brief guide, to promote a basic understanding of lighting techniques based on actual examples complete with diagrams.

For the purpose of clarity and definition, the following glossary of lighting terms is set forth to establish a common ground for all those interested in the basic fundamentals of lighting.

Main Light: The principal light source striking the subject (also referred to as *key light*).

Fill Light: Secondary light source used to accent the subject or fill shadowed area.

Hair Light: Normally positioned behind and above the subject at a 45° downward angle to the subject, it highlights the hair, thus adding greater detail.

Back Light: Accent light, placed directly behind the subject on a direct axis with the camera lens, provides a halo or rim effect, thus separating the subject from the background.

Background Light: Used to illuminate the background to desired degree, and, when color film is used, to control the color of the background. (Generally a broad light source.)

Bounce or Umbrella Lighting: Provides a soft, indirect, diffused light to minimize shadows.

These six basic light types are universal in their application and do not vary with changes in subject, background, color, or location and may be accomplished with photofloods, quartz lights, or electronic flash.

A variety of effects can be achieved through variations in lighting and lighting placement as illustrated by the following basic lighting techniques. (Note: All light meter readings should be taken from main light only.)

*Produced by Smith-Victor Corporation in cooperation with Peter J. Eisele, Eislele Photography, Michigan City, Indiana; Bruce McCullough, Smith-Victor Corporation; Stevan A. Magdaz, Smith-Victor Corporation; with special thanks to Mary Lou Seams.

Flat Frontal Lighting

1. Main light only; light source located on or near camera at eye level (similar to on-camera flash): Subject positioned 6″ from background. Single A120, 500-watt photoflood lamp with DP12 diffusion screen, positioned near camera at eye level 6½′ from subject. (Notice heavy shadow on background.)

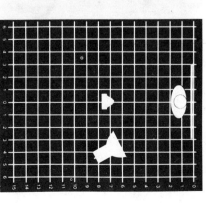

2. Main light only; subject-to-background distance increased: Subject positioned 6′ from background. Single A120, 500-watt photoflood lamp with DP12 diffusion screen, positioned near camera at eye level 6½′ from subject. (This repositioning of subject diffuses background shadow and softens background tone.)

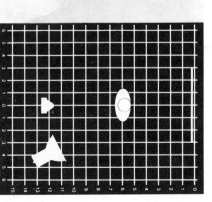

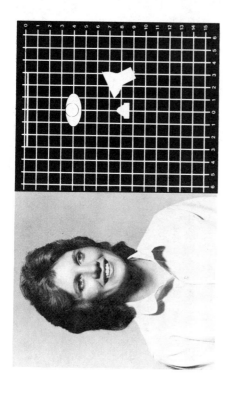

High Frontal or "Butterfly" Lighting

3. Main light only: A glamour lighting technique best suited for women. Subject is positioned 4' from background. An A120, 500-watt photoflood lamp with DP12 diffusion screen is positioned 3' from subject. (Butterfly lighting refers to a butterfly-shaped shadow created beneath the nose achieved by positioning the light source at a 45° downward angle in relationship to the subject's face.)

4. Main light plus fill light: Still using butterfly lighting, an A120, 500-watt photoflood fill light with DP12 diffusion screen, is positioned at a 45° downward angle opposite the main light 7½' from the subject. This light reduces harsh shadows caused by main light and fills in shadowed areas.

5. Main light, fill light, plus hair light: The addition of a hair light, an A50, 250-watt lamp, positioned 3' behind and 3' above the subject at a 45° downward angle, yields an accent on the hair, giving shape and body. (*Refer to photos 18–19 for correct hair-light application. Barn doors are recommended on hair light to prevent light spill on face.*)

6. Main light, fill light, hair light, plus background light: The addition of a background light provides even illumination and separation of background in relation to the subject. An A80 with 500-watt photoflood lamp is positioned directly behind the subject to evenly illuminate the background.

Rembrandt or 45° Lighting

7. This technique utilizes a main light placed at a 45° downward angle, in relationship to the subject's face, and 45° to the side of the subject. The shadow created by the nose is cast over the upper lip to the corner of the mouth, also causing a triangular highlight on the opposite cheek. Subject is positioned 4' from background. A120, 500-watt photoflood lamp with DP12 diffusion screen is positioned 3' from subject at a 45° downward angle to subject's face.

8. Main plus fill light: A120, 500-watt photoflood lamp with DP12 diffusion screen is positioned 7½' from subject at a 45° downward angle.

9. Main Light, fill light, plus hair light: The addition of a hair light, an A50, 250-watt photoflood lamp, positioned 3' behind and 3' above the subject at a 45° downward angle, yields an accent on the hair, giving shape and body. (*Refer to photos 18–19 for correct hair-light applications. Barn doors are recommended on hair light to prevent light spill on face.*)

10. Main light, fill light, hair light, plus back light: The addition of a back light is used to create a halo or rim effect on the subject and to separate the subject from the background. An A50 with a 250-watt photoflood is positioned directly behind the subject to achieve this effect.

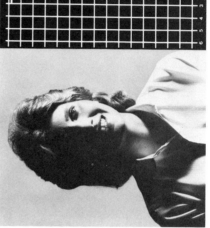
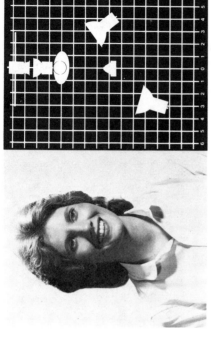
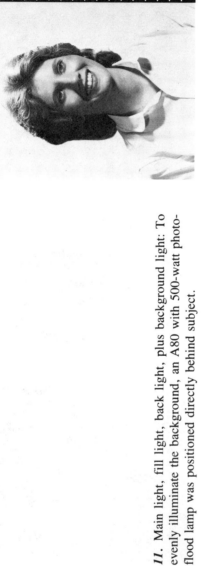

11. Main light, fill light, back light, plus background light: To evenly illuminate the background, an A80 with 500-watt photoflood lamp was positioned directly behind subject.

90° or Split Lighting

This technique utilizes a main light positioned 90° to the side of the subject at eye level to illuminate only half of the face. (*Barn doors are recommended on the main light for this technique to prevent camera-lens flare.*)

12. Main light only; subject positioned 4' from background: An A120 with 500-watt photoflood lamp with DP12 diffusion screen and barn doors is placed at eye level and 90° to the side of the subject.

13. Main light plus fill light: An A120, 500-watt photoflood with DP12 diffusion screen, used as a fill light, is placed 7½' from the subject, near the camera, at a 45° downward angle.

14. Main light, fill light, plus hair light: Hair light is an A50 with a 250-watt photoflood lamp placed 3' behind and 3' above the subject at a 45° downward angle.

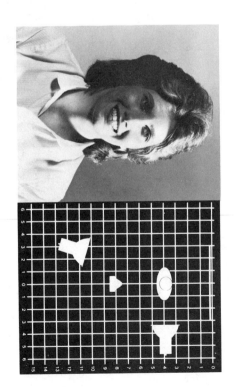

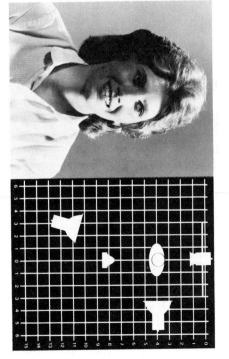

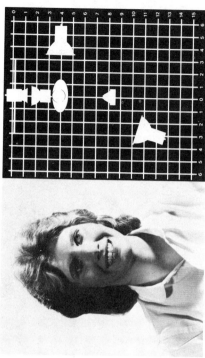

15. Main light, fill light, hair light, plus background light: An A80 with 500-watt photoflood lamp is positioned directly behind the subject to evenly illuminate the background.

Umbrella or Bounce Lighting

16. With subject positioned 4' from background, an A80 with 500-watt photoflood lamp is bounced off a 40" white Pair-A-Sol umbrella. Stand was positioned 3' from subject with umbrella at eye level. (Umbrella position is flexible; two umbrellas are often used and are placed equidistant at 45° opposite angles to the subject.)

Background Lighting

17. Note that background light has no influence on the subject and is used only to light the background.

Hair-Light Placement

18. Incorrect hair light: Hair light is placed too close to the subject, causing undesirable light spill on face.

19. Correct hair light: The hair light properly positioned creates no light spill on face.

Note: Lights must be positioned in relation to the movement of subject to achieve effects shown.

exercises

1. To gain experience in the three types of portrait photography, choose a willing subject and

 a. Set up a formal situation in a living room or studio. Carefully select appropriate background, lighting, props, and so on and execute a formal portrait.

 b. With the subject's help, select an activity or location and execute a portrait photograph while the subject is engaged in an activity or work.

 c. Take a completely candid photograph.
Examine each of the resulting photographs. Which one projects the character quality you strove for? Which does your subject find most appealing?

2. Solicit the help of one or two individuals you know fairly well. With their cooperation, devise a portrait plan designed to highlight one phase of their life or character. Use this plan during the portrait shooting session.

3.
 a. Plan a portrait in which the location tells viewers who the individual is and what his values are.

 b. Plan and execute a "What we do is not necessarily who we are" portrait study. Find a subject who is normally identified by what she does (doctor, police officer, teacher, mail carrier, and so on) and execute a portrait in another context that may give others a fuller understanding of who she is.

4. Ask you best friend to act as a subject. Decide what it is that makes this individual a valued friend. Devise a means of sharing your feelings with others.

5. Choose two portrait subjects and produce a photograph featuring the theme of opposites. Some possibilities are old-young, tall-short, shy-assertive.

6. Put yourself in the subject's place. Attach a long cable release to your camera and position the camera on a tripod. Directly adjacent to the camera, place a mirror so that you can see your reflection. Shoot a series of self-portraits, each reflecting a different feeling or emotion. How did you feel on the other side of the camera? How could a photographer have made you feel more at ease?

7. Select a subject and choose a physical characteristic to emphasize. Plan and execute such a portrait study.

8. Shoot a series of candid portraits that tell a story about one person or a group of people.

9. **a.** Discover the life perspective of one or more children by exploring their world with a camera. Try getting down on your knees and experiencing the world from a child's vantage point.

 b. Stand apart and shoot a series of candids as the kids play and interact with each other.

10. Execute a purpose-designed portrait that points out a social, economic, or political condition of our society. This image may be designed simply to make a comment or to motivate the viewer to change a condition. You may want to study the work of contemporary photojournalists before attempting this assignment.

11. Plan and execute a series of photographs emphasizing the human face and form. Concentrate on form, texture, and line—in other words, on abstract qualities of the human persona.

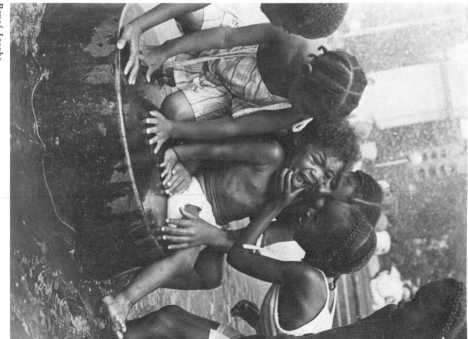

Reneé Jacobs

The power of this image would all but be destroyed if the subjects were aware of the camera's presence.

12. Shoot a series of people engaged in sports or other active pursuits. Emphasize movement, the dynamic qualities of the activity.

13. Draw up a list of six or more human emotions and see if you can portray them on film.

14. Photograph a person within a landscape scene so as to provide a bit of human contrast and function as a scale of reference for the viewer.

15. Shoot one or more photographs displaying a selected quality of a pet or other animal. Answer the following:

a. Is photographing animals much different from photographing people? If so, how?

b. What techniques or equipment would be useful for animal subjects?

c. Are there any special problems inherent in animal photography?

16. Shoot a series of photographs of individuals as reflections in mirrors or other reflective surfaces. How do reflections combine abstraction and reality in one image? Is it possible to use reflection to portray more than one personality?

17. This is an exercise in naturalness. *First,* set up and shoot a more or less routine portrait in the formal mode. *Then,* in the same setting, make the subject part of the process by suggesting that he become an active partner. Try the following:

a. Ask him for input concerning setting, props, pose, and so forth.

b. Ask him what quality he wishes to emphasize.

c. Let him examine the equipment as you explain the process.

d. Take his place as subject and allow him to photograph you.

e. Use music to set a mood.

After processing the two sets of images, evaluate them with the subject. See if either of you discerns any differences in the qualities each set of images projects. Do you think the different shooting atmospheres had an effect? What did you learn about your own approach to your human subjects? Do you need to alter your personal or professional style?

18. Choose one subject you know very well. Make three photographs

a. As you think the individual sees herself

b. As you think she really is

c. As you think others see her

Ask several other people to examine the three photographs. Have them select the photograph that is the most flattering; the most accurate; the least characteristic.

twelve

Overcoming Creative Block

Those new to photography find that ideas pour out of them. They simply can't wait for the next opportunity to use their cameras. Alas, after a while the flood of ideas slows to a trickle, and for some it dries up completely. In the end, many lose interest entirely, the camera finding its way unceremoniously to the closet shelf.

Most photographers have suffered from this malady at one time or another. There is no one solution to this problem we call creative block. One of our primary motives in writing this book is to attempt to prevent, or at least forestall, the advent of these periodic dry spells. In the following exercises we will confront the issue directly.

Essentially, creative block results in two potentially disabling mind sets. The first is an inability to see photographic subjects. A person suffering from this type of block can't seem to see anything stimulating enough to warrant his photographing it. We term this mind set *conceptual block*. The second type occurs when photographers find stimulating subjects but are totally dissatisfied with the resulting images. We term this *process block*. Of the two, we think conceptual block is by far more frustrating and potentially damaging.

Since process block is easier to deal with, we will attack it first. Translating mental images onto film requires a rather precise knowledge of both tools and technique; process block occurs when we fail to fully explore their potential. There are, however, a number of concrete actions we recommend to work through this block. First, analyze the purely technical aspects of the photographic process as you practice it—film processing, lens choice, focus, camera handling, and so on. Once you can eliminate technical considerations as the source of the problem, next examine your technique—your choice of perspective, lighting, exposure, and so forth. If you have still not discovered the problem, consult more experienced photographers and have them critique your photographs and picture-taking technique. Someone in a local camera shop may be of some help to you. Another troubleshooting resource is the library. A book or back issue of a photography magazine may hold the answer. Finally, consider a photography course taught by an experienced teacher if one is available in your area.

Now let's tackle the more thorny issue of conceptual block, or idea burn-out. The core of the problem is not the lack of photographic subjects but rather the dearth of imaginative ways of seeing them. Unfortunately, many of us slip easily into patterned or routinized ways of thinking that stifle our creative intuition.

Kathleen Kissick

Variation on a theme: paladium prints.

Why is this? Some of the answer lies in the way our brain operates. Current research indicates the brain has two halves, each operating for the most part in different modes. We make rational, objective decisions demanding yes or no, go or no-go answers with the left side of the brain. Research has demonstrated that right-brain functioning is instinctive, subjective, relational, holistic, and time-free. So, there is scientific evidence of the creative potential of right-brain orientation. But most of us were educated in a school system that has a definite left-brain bias. And an education stressing left-brain thinking patterns tends to cultivate the verbal, analytical, and rational at the expense of the creative, expressive self. There simply aren't many courses in imagination, creativity, visualization, intuitiveness, or perception available to students. For many, right-brain potential exists in abundance but simply stagnates.

So, to overcome conceptual block we need to draw on our right brain, our more primitive, metaphoric self. We simply cannot take a left-brain approach to the problem. In fact, one could argue that right-brain thinking cannot be taught through traditional pedagogy. Virtually all right-brain development is by its nature *experiential*. But because of our culture's left-brain orientation, this is a very difficult process for many of us. The process involves breaking away from our patterned, routinized left-brain thinking and allowing a new type of thought to direct our vision.

The following exercises are designed to help you to begin this process; to open your mind to new ideas and concepts; to exercise the creative side of your brain. Whereas they address conceptual block specifically, most of the other exercises in this book can be applied to this problem as well.

exercises

1. Keep a notebook for jotting down random ideas as they come to you. When you see something interesting or get an idea, write it down immediately before it fades away. Don't expect to use all of the ideas—you probably won't.

2. A variation of idea collection is free association. Without a camera, study scenes that contain inherently photogenic qualities—unusual light, pleasing form or shape, interesting texture, and so on. See if you agree with photographer/author Andreas Feininger, who argues that the most appealing photographs contain these qualities. Although we do not totally accept this point of view, it may help you see some interesting images. In practice, this mental imaging is quite easy. Simply store the photogenic qualities you perceive and try to imagine how you would use them to design a stimulating photograph.

3. While studying a scene, list the objects in your field of view. Beside each, write a word or phrase describing one of its qualities that you would emphasize in a photograph.

4. Select a subject quality such as shape, form, color, or texture. Shoot a roll of film containing images emphasizing that one quality exclusively.

5. Review your photographs for the last year or so. Choose a few frequently photographed subjects and answer the following questions about them:

a. When I take pictures of _____ I always seem to _____. (*Example:* When I take pictures of flowers, I seem to include too much foreground.)

b. My _____ photographs would mean more to me if _____. (*Example:* My flower photographs would mean more to me if they seemed to float in air).

c. To make my ——— ——— photographs mean more to me, I need to ———. (*Example:* To make my flower photographs mean more to me, I need to devise a way to have them detached from the background.)

d. Maybe I should try ———. (*Example:* Maybe I should try a combination of shallow depth of field and soft-focus filtration.)

e. (if that didn't work) Let's try ———. (*Example:* That didn't work. Let's try a different perspective.)

Although these statements might not solve the problem at hand, they should give you a framework in which to search for ideas and variations that will help you evolve new processes or techniques.

6. This is an activity originally suggested in the writings of photographer Minor White. Choose a common subject and photograph it so as to portray it representationally—that is, as the subject is traditionally seen. Then devise a plan to portray it as something else. For example, select something inherently beautiful and photograph it so it appears ugly. In other words, select a subject and describe it as one might expect, then use an opposite or nonrepresentational meaning as the basis of a photo concept.

7. Have a friend select three or four unrelated objects. Study the objects and try to discover symbolic or material relationships uniting them visually. Design a photograph that highlights this discovered relationship.

thirteen

Learning to See through the Work of Others

Historically, art observers and critics point to the uniqueness of an artist's vision as one factor that separates him from his peers. How does an artist's style become uniquely his own? Obviously, hard work and practice are important. But many artists point to the influence of significant individuals, particularly other artists, on their artistic evolution. Those whose work we admire can influence our perceptions, provide us with new and exciting visual experiences, and motivate us to strike out into new areas of expression. In the following exercise you will analyze the work of other photographers so that you can

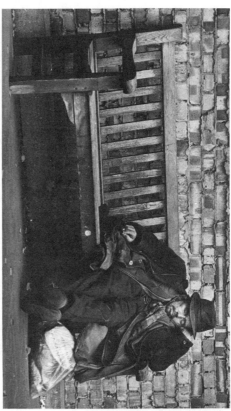

Jim Jennings

From these photographs, what can you tell about how this photographer works?

1. Discover what special techniques, perceptions, or philosophy each project through his or her work.

2. Learn to appreciate the unlimited variety of perspectives available to the keen observer.

3. Take what is valuable in the work of others and incorporate it in your own learning and growth.

exercise

Choose a photographer whose work is readily available in archives or libraries.

1. Study his or her work from a historical perspective: How did style, technique, and content change over time?

2. Identify what it is about his or her style that sets him or her apart. What do the works tell us about his or her values? Does the work give us any insight into human nature or natural beauty? If so, how?

3. Does the photographer manipulate our perceptions? If so, how? Is he or she successful?

4. What can be learned from his or her work? Is there anything you wish to emulate?

5. Does anything in his or her work also appear in yours?

6. Has this photographer's work made any contributions to the advancement of photography? What?

After completing this analysis, attempt to produce a number of photographs incorporating some elements of this person's style that you find intriguing. Remember, to grow artistically is not to adopt someone's style wholesale. Rather, it is to learn from others and to integrate the qualities of their unique vision into your creative scheme.

Henri Cartier-Bresson

Modules 14–17 deal with several photographers, both past and present, who have influenced the course of photography. Each represents a different philosophy of the practice and function of photography. To an extent they all "see" their subject differently, but there are also points of similarity in their approaches.

It should be gratifying and illuminating for you to study their work and practice in their style. From these experiences, you may discover some sense of your own stylistic preferences. Along with the exercises in these modules, work through those in modules 13 and 19. These experiences represent a range of opinion on and a number of approaches to photography. Though not all-inclusive, they demonstrate the variety of options open to you as you define the relevance of photography to your expressive goals.

The Decisive Moment

"In photography, visual organization can stem only from a developed instinct."

It was the internationally renowned photo essayist and practioner of reportage Henri Cartier-Bresson who coined the term *the decisive moment*. To Cartier-Bresson, simultaneous recognition of the significance of an event *and* the ability to give the event proper expression is, for photographers, the decisive moment.

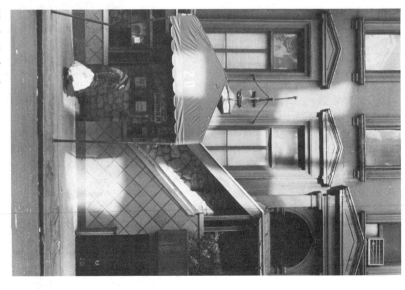

Charles Puckey Jr.

One must anticipate the decisive moment. (*Continued on next pages*)

Charles Puckey Jr.

Marc Levey

One must anticipate the decisive moment.

Cartier-Bresson considered himself an onlooker, somewhat detached from the events unfolding before him. He would go to great lengths to make himself and his camera unobtrusive. Unlike the photojournalist who concentrates on the sensational, Cartier-Bresson focused literally and figuratively on typical events, seeking out ordinary people in everyday life. Cartier-Bresson believed the camera functions only to freeze our experiences, not to comment on them.

He shied away from artificial light such as flash, preferring instead fast film and large-aperture lenses. Most often he would use a Leica range-finder 35mm camera with a 50mm f2.0 lens. This combination suited his style admirably, for it was compact and delivered negatives expressing a perspective approximating what the eye normally sees. He chose to edit and crop in the viewfinder, rarely cropping prints in the darkroom. To him, the complete image was contained on the negative. Others printed his work under this direction after he examined and selected frames from a contact sheet. In fact, Cartier-Bresson would avoid darkroom work entirely if he could. He felt his time was spent more productively behind a camera than over an easel. To him, straight and "honest negatives and prints are the only way to tell a story with pictures."

Critics point to the seeming naturalness of his images. Even though Cartier-Bresson reacted intuitively, he exhibited an uncanny visual organization and rhythm in his prints. All of their visual elements blended harmoniously, as if painstakingly preplanned.

He once said "We cannot develop and print memory. What is gone in an instant can never be retrieved." Thus, we are compelled to perceive our special reality and record it all but simultaneously. Cartier-Bresson has expressed the belief, both in words and in images, that only through keen observation and sensitivity to unfolding events can we hope to capture the decisive moment on film.

exercises

1. Cartier-Bresson's work has been criticized for its detachment. Is this a valid criticism?

2. Is Cartier-Bresson's modus operandi of being totally unobserved the only way to portray people naturally?

3. Does luck play any role in Cartier-Bresson's approach?

4. Attempt Cartier-Bresson's approach by shooting an entire roll of film with a fast normal lens. Look for ordinary subject matter and concentrate on the interactions between the picture elements. Print the photographs without cropping them.

5. Of the other photographers whose work you have studied, who would be most like Cartier-Bresson? Most unlike? Don't consider the result, but only the process.

6. Is it possible to plan for or anticipate the decisive moment? Is it better just to react to unfolding events and interactions intuitively?

fifteen

The Direct Approach:
Edward Weston
and the f64 Group

Kathleen Kissick

Close and detailed seeing typify the f64 approach to photography.

In the early 1930s Edward Weston formed a loose association of photographers that was to become the f64 group. Closely allied with Weston were Ansel Adams, Imogene Cunningham, and others who were to leave their marks on the course of photography for nearly three decades. These individuals, especially Weston and Adams, became advocates of a brand of photographic expression known as the *direct approach.*

The work of the f64 group and their adherents is characterized by straightforward imagery of exceptional sharpness and depth. Their aim is to clarify seeing by presenting images in intimate detail, emphasizing fine gradations of tone and texture. Weston and now Adams have become apostles for the previsualization of tonal relationships and design. Several contemporary photographers have carried the f64 philosophy into color work, the most notable of these being Eliot Porter.

Although many praise the relative merits of this intimate, detailed way of seeing, others, including the critic A. D. Coleman, question this approach as being too confining in terms of both subject matter and manner of execution. Coleman goes so far as to assert that Weston "will eventually be seen as an awesome, monumental boulder in the path of the evolution of photography in the twentieth century." He argues that Weston and his followers misunderstood the essence of photographic communication, confusing the subject as experienced with its photographic image as seen.

The fundamental question raised by this debate is whether any photograph can be a totally objective statement. We believe not. However, consensus does tend to establish a more or less universally accepted meaning for many photographic images. Whether this meaning is objective remains unclear. Weston's notion that the print becomes the object is difficult to support. There is just too much difference between experiencing something in real life and viewing it as a two-dimensional photograph to suggest that both experiences are the same. Neither is better, worse, or more or less inspiring; they are just different.

Whether we accept or reject their underlying premise, we should recognize that Weston, Adams, and their followers have given us a legacy of excellence. Their work can teach us much about the virtues of flawless execution, pureness of motive, and directness of approach. While not "the way" for most of us, the direct approach gives us a point of view not without merit.

In his writing, Weston is not clear as to whether he intended his work to replace first-person experience. His written words imply that one must first understand what a subject means to him before photographing it. He defends subjective image making rather than the elitism of total objectivity.

Thus, one could argue that there is no one absolute, unqualified value in an object that must be transferred from experience to print in order for a photograph to be valid. A photograph is what we, both as viewer and photographer, choose to make it.

exercises

1. Choose a landscape scene. Define it as you think most individuals would; that is, define what its fundamental reality is for most people. Select the tools and techniques to demonstrate this in a photograph. Ask a number of individuals to react to the print. Is it possible to exhibit "fundamental reality" in one print? Does consensus constitute fundamental reality?

2. Shoot a roll of fast black-and-white film, emphasizing subject detail and depth. Use a wide-angle lens at its smallest aperture. Predetermine the tonal values you wish to have in the final print and adjust the exposure accordingly.

3. Is there such a thing as objective reality? If so, what is it? If not, how close can we get to it?

4. On the surface, the direct approach and the futurist approach (represented by Uelsmann, Siskind, Ray, and others; see module 19) appear at opposite ends of the expressive spectrum. Can you find any commonality between them? More important, is it necessary to have any philosophical framework at all? Does strict adherence to any school of thought limit our creative options?

5. Study the works of Edward Weston and Ansel Adams.

a. What qualities in their work do you admire, if any?

b. Does their choice of "traditional" subject matter detract from their impact today?

c. Do you think the criticism of their work is justified?

d. What applications of the direct approach are useful to you?

W. Eugene Smith

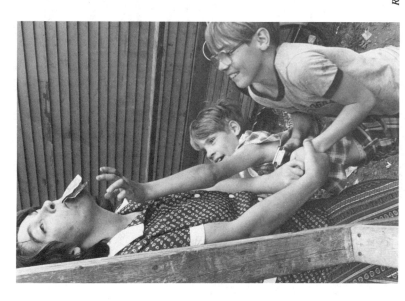

Reneé Jacobs

Often spoken of with reverence by his contemporaries, W. Eugene Smith has made an indelible mark on the practice of photojournalism and documentary photography. Some suggest that his work, especially his photo essays—*Spanish Village*, *Nurse Midwife*, and *Minamata*—represent a standard of excellence rarely if ever achieved by photojournalists past or present.

Why does Smith, who died in 1978, exert such a profound influence on reportage? The answer, we think, can be found not so much in his photographs, which are eloquent statements of the human condition, but in his attitude and ethics. Smith did not see himself as a mere photographer, carrying out defined assignments. All his life he fought the idea that how his images were to be used should not be his concern. Instead, he demanded the right to exert editorial control over copy, captions, and even layout. On more than one occasion, this insistence brought him into direct conflict with controlling powers at *Life* and elsewhere.

His insistence on expressive independence is easy to understand once we examine his philosophy. Smith was not a passive observer; he became intimately involved with events and people. His philosophy contrasted markedly with the photojournalism prevailing immediately after World War II. Instead of a nonpartisan, observational stance he opted for a position of committed advocacy, using his photographs to express his beliefs. His journalism was subjective; it was to be used as a catalyst for social change.

involvement and empathy with the subjects.

Unlike Cartier-Bresson, Smith would utilize any light, lens, and camera if it served his purpose. He preferred soft, indirect light, and many of his images display his fondness for low-key, detailed blacks. He was a wonderfully skillful printer as well as photographer, and to appreciate the shimmering quality of a Smith print one needs to experience the original. Reproductions simply do not do justice to his work.

It is difficult to put W. Eugene Smith's work into a photographic category. Obviously, it transcends the express purposes of photojournalism. One piece, "Tomoko in Her Bath"—a Japanese mother tenderly bathing her terribly deformed child—has been described as the most powerful weapon against pollution yet devised. It will far outlive the hundreds of commonplace images seen in newspapers and magazines.

In spite of all the respect his work and philosophy receive, very few of today's photojournalists demand or are granted even a fraction of the creative freedom Smith enjoyed. It's business as usual.

exercises

1. Compare and contrast the philosophies and styles of Henri Cartier-Bresson and W. Eugene Smith. Which approach do you feel is more representative of your attitudes toward photography? Is one necessarily better than the other?

2. Is it possible to be as independent as Smith was? Could you suggest a reasonable compromise?

3. Select something in your community that needs changing—for example, a pothole, waste dump, or dangerous intersection. Plan and execute a photo or photo essay in the style of W. Eugene Smith. Attempt to get your work published in a local paper. Insist on some control or input into the entire project. Afterwards, answer these questions:

a. What obstacles did you encounter during the actual picture taking?

b. What reaction did you get from the editors of the paper?

c. Were they willing to publish your material? Did they give you a voice in decisions, layout, captions, and so on?

d. Have you learned anything about the press establishment? What?

Andre Kertesz:
Photography with the Light Touch

Falling somewhere between Henri Cartier-Bresson's detachment and W. Eugene Smith's total involvement, Andre Kertesz has photographed subjects ranging from simple snapshotlike scenes to surreal nudes. One of the first to use the small hand-holdable camera in his work, he has since been credited with fathering the "candid" motif. Interestingly, Kertesz does not subscribe to any school or theoretical position, and his images do not give us any clue to his inclination. He can best be described as an eclectic.

There is something special about a Kertesz photograph. The images are a mirror of his attitude—a little boy marveling in the wonder of discovery. Rather than heavyhanded subjects or themes, his camera captures ordinary people but in an extraordinary way. Even the documentary photographs he took during World War I project a humanity and gentleness that belie the subject matter. Kertesz wasn't interested in contemplative, intentional photography. Instead, he sought the ephemeral instant where the commonplace suddenly becomes the totally unexpected. His eye, mind, and soul were so tuned to those moments that he reacted to them instinctively.

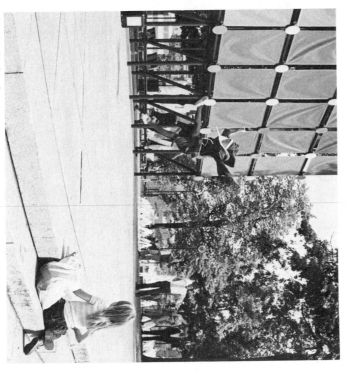

Charles Puckey Jr.

Would this image have appealed to Kertesz? Why, or why not?

Thus, a reclining woman becomes more than another figure study: She is a flight of whimsy, a light, delicate thing we smile at and don't know why. It is this sweet childlike affection Kertesz brings to his craft and shares with us that endears him to so many. Even during the short time he spent working with surreal nude studies, the characteristically light touch was always in evidence. The figure distortions he created were in no way grotesque. They were fun.

Like the Dadaists, Kertesz often found life absurd. But rather than picture life angrily, he chose to make fun of it. In his work we constantly discover evidence of his subtle wit.

In Kertesz we have an acknowledged giant who evolved naturally and spanned the gulf between objective and subjective, interpretive and documentary. His images help us understand a man who truly loved life. When you study his photographs, look for love; it's there.

exercises

1. One of the most difficult human experiences to capture in a single frame is humor. Your task is to observe and attempt to find events, people, or situations that make you laugh or at least smile a bit. Don't hesitate; shoot them.

2. Like Kertesz, look for ordinary people in unexpected situations or poses. Try to condition your eye to expect the unexpected. Just a slight change in vantage point might allow a new way of observing and photographing.

3. Photograph ten scenes that represent different loving relationships.

4. Think of places where people have fun. Select one. As you shoot a roll of film try to enjoy the moments with your subjects. Let your camera laugh along.

5. How can visual humor help shape social and political opinions and attitudes? Cite examples. Try to design and execute a humorous photograph having larger social implications.

6. Does formal education in the arts (Kertesz had none) retard or advance artistic growth?

7. What are the virtues and liabilities of being self-taught?

The Image and the Word

Photography, like any form of communication, can inform, persuade, entertain, teach, and more. Although it can communicate by itself, a still image can enhance or be enhanced by being skillfully blended with the written or spoken word. We are exposed to this technique dozens of times every day; one need only turn on the television or glance at a magazine.

In word-image communication, the still photograph functions in much the same way as the melody of a song. Words and music often communicate well independently but become something special together. Most of us lose sight of the unique creative possibilities of word-image communication because most of what we see of this medium is commercial.

Once in a great while a book comes along combining visual images and words so skillfully, with so much sensitivity, that its message is inescapable. Such a book is Donald McCullin's *Is Anyone Taking Notice?* Combining McCullin's words and incisive imagery with Alexander Solzhenitsyn's telling verse, this book transcends its photographs and poems. It is more than the sum of its parts. We urge you to find a copy of this book and study it. Read the words and the pictures. Be warned! The images are anything but pretty. But they speak a truth about cruelty and despair that is impossible to reject. The photographs are even more gritty juxtaposed with Solzhenitzyn's words. Prove for yourself that the word-image can do more than sell soap.

Time slipping through time
Never a starting
or ending post
Just a beginning
in the end.

Charles Puckey Jr.

Image and verse can support each other.

exercises

1. Select some prose or verse you enjoy. Supply one or more images that reinforce the words. Although you can use images previously taken, you may wish to produce photographs specifically for this purpose.

2. Reverse the procedure of exercise 1. First select one of your images and then choose appropriate verse or prose to reinforce the theme. In both exercises, experiment with methods of presenting the word-image.

3. Answer the following questions:

 a. Which exercise was more difficult, 1 or 2? Why?

 b. Do you agree that images should be able to stand on their own in order to be worthwhile? Why? Why not?

 c. Cite instances where a combination of words and pictures strengthen the impact of communication.

 d. Can you think of any other multidimensional modes of communication?

nineteen

The Photographic Innovators

The beginning of the twentieth century witnessed extraordinary innovation and change in art. Coming as they did at a time when photography was finding wider acceptance, the new ideas and philosophies were bound to influence this young medium. Not content to depict subjects representationally, many photographers struck out in new and, to some, bizarre directions.

The work of the artistic innovators, photographers included, was often condemned by establishment critics as no more than degenerate expressions of art. To others, however, their vision was fresh and in many ways visually challenging. Challenging conventional vision, they offered innovative ways of seeing a rapidly changing world.

In the early 1920s the Hungarian-born artist Moholy-Nagy came to the Bauhaus (the architectural school founded in Germany in 1919 by Walter Gropius, and the hub of nonconventional, experimental art). Rather than accept photography only as a recorder of real-world images, accurate in detail, scale, perspective, color, and so forth, Moholy-Nagy began to experiment with new modes of photographic expression. Some of his techniques, such as solarization, multiple exposure, and double printing, were considered revolutionary, almost to the point of heresy. But he persisted and pointed the way for others who followed.

Harriet Rosenberg

Sun prints, or solarizations, reminiscent of Maholy-Nagy and Man Ray.

Many photographers have attempted to push aside the barriers of convention, and a few have become famous because of their pioneering ideas. In the past half century, three such individuals come to mind immediately: Man Ray, Aaron Siskind, and most recently Jerry Uelsmann. Siskind, especially in his later work, concentrated on pure form and abstract design, whereas Ray and Uelsmann employed a variety of surreal effects to give meaning to their vision.

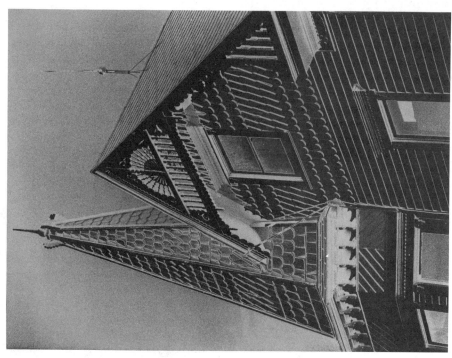

Marc Levey

An example of the Sabattier effect.

Man Ray

An American-born artist living in Paris, Man Ray first achieved notoriety as an abstract painter. By his own admission, Ray tired of painting and found the rising movements in experimental photography more to his liking. His photographic work reflects his penchant for abstract form and his fascination with the relationship of light and space.

Ray was drawn inexorably to Dadaist philosophy. Dadaists believed contemporary life was absurd in the extreme. Thus, an artist's work, to have an impact, had to be even more absurd. Like Moholy-Nagy, Ray utilized solarizations and photograms (which he named Rayograms). His photographic work has been forever associated with these modes of expression.

Aaron Siskind

Siskind achieved early fame as a documentary photographer. His early work stressed visual reportage and a preoccupation with content. This type of photography did not satisfy his deep-felt need to freely explore and express more subtle relationships of space, line, form, and light. Perhaps it was his close relationship with the abstract impressionist de Kooning that helped him revise his vision. He abandoned subject matter as his primary focus and began an intensive exploration of natural relationships. He became excited by the visual impression derived from examining a limited portion of space. To him, relationships among visual elements— form, line, light, and space—rather than the things themselves gave meaning to his special brand of seeing.

Jerry Uelsmann

A master of the montage, or composite image, Uelsmann creates images having both representational and fantasy elements. Uelsmann's photographs remind one of cubist visions of simultaneous, multidimensional views of a single subject, not only in content but in meaning. Almost all of his images are derived from his inner consciousness. Many are brooding, almost frightening visions of a surreal landscape.

In his darkroom, Uelsmann can fit many fragmentary images into a composite expression that transcends the individual meanings of any one image. Uelsmann has no firm idea of how an image will be used when it is first taken. It's only in what he calls the post-visualization—the actual making of a composite—that he blends individual images to form a visual statement.

exercises

1. Choose a photographic technique such as multiple exposure, paste-up, or photomontage and construct an example of the cubist principle of simultaneous multidimensionality. Offer the finished work to others for reaction and critique.

2. *a.* Depict the passage of time in one photograph.

b. Imply motion in one photograph.

Whereas the passage of time could consist of any number of events, a photographic motion study could be made of one event, or even a portion of it.

Either motion or passage of time can be used in two ways in a photograph. First, it can be a central theme along with content. Second, it can be used as a subtheme to underscore some quality of the subject that we wish to draw to the viewer's attention.

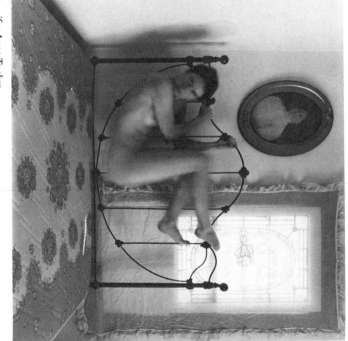

Jennifer Anne Tucker

This image has an Uelsmann-like quality to it.

Steven P. Mosch

Seeing the unseen—sometimes photography transcends human vision, as with infrared film.

3.
 a. Examine the work of Man Ray (especially his early photographs). See if you can find evidence of Dadaist influence. Try to execute a photograph in the tradition of Man Ray.

 b. Study Jerry Uelsmann's photography. Choose several of your own negatives or transparencies and construct a composite that expresses more than the meaning of any one of the images.

4. Execute a photograph in which you emulate the style of Aaron Siskind. Visually explore your reaction to one or several physical relationships in a limited amount of space.

5. Consider the following questions.

 a. How does photography provide us with opportunities to "invent" images?

 b. How does one decide between a realistic or an abstract rendition of a subject?

 c. What subjects lend themselves to nonrepresentational treatment? Why?

 d. What is the role of instinct in the creative process?

 e. To what extent do innovative photographers such as Ray, Siskind, and Uelsmann conform to your view of what photography should be? To what extent don't they represent your view?

 f. How would you defend or oppose critics who assert that the innovators in photography rely on visual gimmicks?

 g. Did you have trouble seeing abstractly? If so, why?

Eva Rubinstein:
Discovering Who You Are

Sigmund Freud is reported to have said, "All dreams are wishes." If he was correct, and many think he was, then dreams possibly represent who we want to be. Could it be that many photographs are manifestations of our dream world? Probably so! Many believe they can, like Freud's dream interpretations, tell us a great deal about who we are.

An entire photographic style has grown from this assumption. In its forefront is Ralph Hattersly. In his writing he postulates that thoughts, wishes, desires, fears, and prejudices buried in the subconscious somehow find their way onto film. We need only discover them in our photographs to know ourself.

Applying traditional psychoanalytic theory to photography is in vogue these days. But like any theory, it is one thing to espouse it and quite another to prove it. If nothing else, we are willing to support the notion central to this philosophy that photographic images frequently contain autobiographical elements. It follows that most photographs we take are bound to represent our basic attitudes and predispositions at least to some degree.

It is fascinating to examine the work of a talented photographer who claims to have discovered so much about herself through careful analysis of her own work. One such person is Eva Rubinstein. She firmly believes there is a direct and observable link between her life experiences and her images. She would not balk at this statement: To experience a Rubinstein image is to experience a great deal of Rubinstein. Ms. Rubinstein discovered several recurring themes in her work that she feels could be related only to some of the darker moments in her life.

From her own account we learn something of her fragmented and somewhat lonely childhood, in which she lived in the shadow of her famous father, pianist Artur Rubinstein. Her photographs of mirrors that reflect nothing, empty rooms, children by themselves seemingly unable to connect with playmates are for her striking examples of autobiographical images. For Rubinstein these images mirror past experiences in the present. They are visible clues to the state of her psyche at the time they were taken. Not surprisingly, these recurring symbols directly express earlier fears and anxieties.

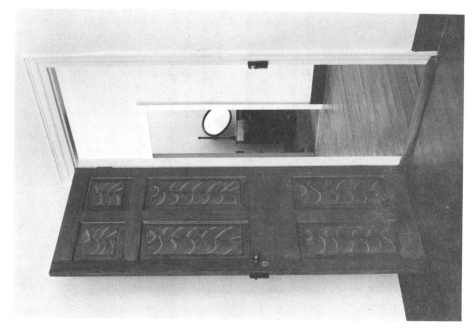

Charles Puckey Jr.

Kathleen Kissick

All of our photographs reflect something of our values, feelings, and experiences.

A comparison of Rubinstein's early and later work reveals a gradual shift in style and content. Her preoccupation with a brooding shadow world is all but gone in her later work. Instead we see a softer, simpler, and upbeat style. The images are more expansive and open. Does this indicate personal change? Eva definitely thinks so. If her early work is a lament, her later efforts might signify a growing ease with herself, an assurance that comes from knowing more clearly who she is. At least in Eva Rubinstein's case, choice of style and content parallel emotional development. By her own admission, the correlation is striking.

exercises

1. Eva Rubinstein says we share ourselves through our art. To what extent do you think another person can know you by looking at your photographs? What are the assumptions that person must make? Are there pitfalls to such an approach?

2. Examine photographs you have taken over a period of years. Do you see any recurring themes? What symbols, if any, are present? Were you aware of them? What do they signify about you, if anything?

3. Cartier-Bresson and Weston strove for objectivity—detachment from the subject. Rubinstein represents the opposite side of the coin. Her images are intimate and self-revealing. Where do you place yourself on the objective-subjective spectrum? Do you feel at ease where you are?

4. Attempt to create a photograph that evokes a timeless quality, an image whose subject defies dating and has appeal now and in the future.

5. To what extent do you feel you have discovered useful knowledge of yourself through your photography? Do we place too much emphasis on self-discovery?

6. Why do we choose the subjects we do? Why do we depict them in a particular way? What, if anything, does this say about our beliefs and values?

The Persuasive Photographers

Steve Williams

Effective advertising begins with top-quality photographs: Savings and loan.

After four years of study at a university, a friend confessed that he has had to learn an entirely new way of seeing in order to survive in commercial photography. Although much of the history, aesthetics, and philosophy of photography he eagerly immersed himself in during his college years was not a waste of time, his education did not give him the perceptual skills and attitudes necessary to make a living from photography. His admission does nothing to devalue his fine-arts education. It only points out the need for more varied programs addressing both photography as a fine art and the more pragmatic skills of the craft.

Although purists may violently disagree, we find a great deal of photographic innovation and creativity between the covers of leading consumer magazines. Even though it serves to further what for some are dubious goals, the work of Richard Avedon, Bert Stern, Irving Penn, Victor Skrebneski, and other commercial photographers has been recognized as going far beyond a commercial function.

Admittedly, photographers such as these have their roots in fine art, but they have learned to see in another dimension as well. They have grown to understand how to sell a product or concept with an image. Some critics refuse to consider such photography as art simply because it is commercial. We suggest to them and you that the principal functions of art are to evoke feelings in the viewer, please the aesthetic sense, motivate individual action, and convey something of the human condition to others. If you can accept any or all of these propositions as valid, then commercial photography should not be excluded simply because of the use to which it is put.

Restaurant. Agricultural Extension conference.

Even though the overt purpose of advertising and fashion photography is to create a need for a product or a belief in an underlying message, the resulting images can and many times are so skillfully and perceptively executed that they transcend commercialism.

Operating in the Commercial Mode

The men and women who practice the trade are first and foremost consummate craftspeople. Aside from their skill, they must see in somewhat different terms than other photographers. Seeing, for advertising photographers, is almost always conditioned by an overall motif, a residual message.

By and large product photography is a careful, step-by-step procedure. Little is left to chance. Artistic interpretation for these very disciplined photographers is of necessity secondary. It is photography by design. By this we mean design in its literal sense—every step planned and rehearsed—and design in its figurative sense—photography with a purpose.

Seeing Pragmatically

Seeing for fashion and advertising photography consists of two separate but eventually converging paths. The first is the creative, interpretive path that we can call *the path of artistic desirability*. The second is what we call the *path of the possible*—that which is conditioned by the express needs of the client. What may be desirable on an artistic or aesthetic level may not be possible when one is working within the constraints of the commercial system. What often results is imagery arrived at by the photographer finding the common ground between what is artistically desirable and what is pragmatically possible. To be successful, the commercial photographer must see on these two levels simultaneously.

exercises
part a

Your task in these exercises is to begin seeing as a commercial photographer might. Try to think in terms of the desirable and the doable.

1. Pick out one or two ads in a magazine. Determine their concept or message. Execute several photographs as alternative illustrations of the concept. Since time is usually one of the constraints in the commercial world, give yourself a limit—for example, allow only one week from inception to finished print or transparency.

2. Choose several commercial illustrations you find particularly effective. Determine how the images create a character for the product or idea. Does the photographic style, technique, or design become a way to identify the product? If so, how? What products or services can you list that have become well known simply because of how they are illustrated in an advertisement?

3. How is color used to attract attention? What colors seem to predominate in commercial illustration? Why?

4. Your college or university is in serious financial difficulty. Your assignment is to provide an illustration to be used in a one-page appeal for funds to save old alma mater. Devise a photographic plan and execute the image. Suggest some copy to go along with the illustration. Remember, money is tight! Black and white is all the school can afford.

5. Remembering the discussion of the path of artistic desirability and the path of the possible, answer these questions concerning exercise 4.

a. What was the desirable?

b. Was the desirable doable? If not, why not?

c. What were the constraints on the project? How did you attempt to overcome them?

part b

A new jeans and sportswear company wishes to promote its line of active wear, casual clothing, and accessories. The company decides to stress a sort of reverse snob appeal in its advertising campaign and to emphasize no-name, no-symbol clothing. Your job is to design ads that will somehow make these no-name clothes unique and readily identifiable in the marketplace. These products will be sold nationally to high-fashion–conscious males and females in the 15–35 age group. Your client wishes the product to be synonymous with quality, class, and upward mobility. National ads for these products will appear in *G.Q.*, *Vogue*, *Seventeen*, *Playboy*, the *New York Times Magazine*, and *Sports Illustrated*.

1. Do you have enough information to complete the assignment? If not, what else do you need to know?

2. Lay out a design that includes

a. Location

b. Models (sex, age, number, and so on)

c. Dress

d. Props

e. Activity

f. Equipment

g. Lighting type

h. Format

Be sure to supply a rationale for choosing each of the above. Be prepared to defend your plan before the art director/committee.

3. Assemble crew, equipment, models, props, and the rest and execute the ad photograph. Design and administer a suitable mechanism for determining the impact of your image. Submit the finished photograph to the art director/committee for final review and critique.

The Psychological Impact
of Color

Color is everywhere. We are bombarded by colors every moment of our lives. Most of us even dream in color. But we rarely consider how color itself influences our perceptions.

Marc Levey

Can we predict which subjects will be rendered more effectively in black and white and

Marc Levey

which in color?

Marc Levey

An example of color itself dominating an image.

Jim Lloyd

The impact of color photography depends largely upon the choice of exposure and how the colors interact in a scene.

Color can be subtle as well as startling.

Marc Levey

Marc Levey

COLOR WHEEL AND COMPLEMENTARY COLORS

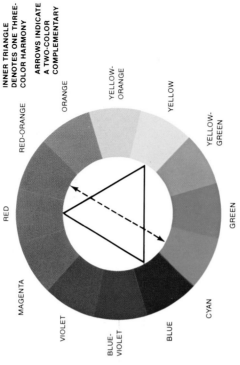

INNER TRIANGLE DENOTES ONE THREE-COLOR HARMONY

ARROWS INDICATE A TWO-COLOR COMPLEMENTARY

ORANGE
YELLOW-ORANGE
YELLOW
YELLOW-GREEN
GREEN
CYAN
BLUE
BLUE-VIOLET
VIOLET
MAGENTA
RED
RED-ORANGE

The color wheel shows the relationship between complementary and adjacent colors.

PSYCHOLOGICAL EFFECTS OF COLOR ON HUMAN PERCEPTION

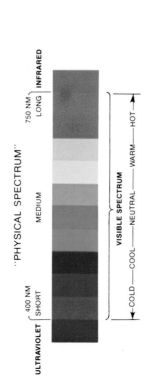

ULTRAVIOLET
400 NM
SHORT

"PHYSICAL SPECTRUM"

MEDIUM

750 NM
LONG

INFRARED

VISIBLE SPECTRUM

COLD — COOL — NEUTRAL — WARM — HOT

From Marc Levey, **The Photography Textbook,** *1979. By permission of Amphoto.*

Visible light ranges from the violet in the 400nm wavelength to red in the 700nm end of the spectrum. Colors possess psychological impact as well as physical properties.

Consider that the term *color* itself is quite relative when applied to a particular region of the visible spectrum. Perceptual psychologists have demonstrated that we all perceive specific colors differently. The threshold where one person describes a hue as pink and another as red varies widely and is almost totally arbitrary. We have little color memory, but only a generalized, associative understanding of a range of shades and tints that we describe as a particular color.

So what we have is a color system where portions of the visible spectrum have been assigned names such as *red, blue,* and *yellow* as a matter of convenience. These color names cover a wide range of shades and tints on either side of a scientifically measurable point. As the hue of a particular color changes, so too does the impression it invokes in the viewer.

The use of color to support a feeling or idea can be effective if done with some knowledge of its probable impact. The following exercise aims at some understanding of and appreciation for the feelings evoked by specific colors.

exercise

A. The first part of your task is to match a list of general and specific color conditions with a list of feelings or responses they might generate. You will have to consider not only the color itself but its location in a photograph and the volume of space it occupies. More than one description may be applied to a color.

1. Small spot of blood red
2. Large expanse of blue
3. Large expanse of green
4. Black highlights
5. Brown foreground
6. Large red mass
7. Highly saturated violet content
8. Yellow-green
9. White highlights
10. Gray
11. Green against black background
12. Blue
13. Orange in shadows
14. Orange in direct light
15. Green in foreground
16. Blue-green in shadows
17. Pink highlights
18. Beige
19. Aqua mass
20. Yellow highlights in direct light

a. Harmonizes with all colors
b. Light, young, airy
c. Demands viewer attention
d. Dull, somber
e. Stable natural, supports warm colors
f. Overpowers senses and content
g. Excellent accent
h. Cool, natural, unobtrusive
i. Makes all other colors appear brighter, richer
j. Somber, regal, formal
k. Makes all other colors appear less saturated and rich
l. Naturally belongs in background
m. Happy, warm, very light
n. Rich, warmest of all, happy
o. Takes on added significance
p. Very cool, especially darker shades, formal
q. Not a color
r. Chromatically neutral
s. Seems to advance
t. Seems to recede
u. A natural foreground color
v. A natural background color
w. Can be violent
x. Most "natural" of all colors
y. Neither warm nor cool
z. Lightest of all colors

If you had trouble with this exercise, study the illustration on the facing page.

B. Examine a number of color photographs for examples of color used effectively and ineffectively. Use the list in exercise A as a guide.

C. Select five items from exercise A and shoot a series of photographs illustrating how color can evoke specific psychological responses in the viewer.

twenty-three

The Dominant Hue: A Powerful Mood Setter

All color films react to the color spectrum differently. In the case of color-negative material, the difference between film types is masked in the printing process and by the skill of the printer. Transparency films, however, employ more or less standard chemical processing and exhibit color characteristics inherent in the emulsions themselves. Although differences in color rendition from emulsion to emulsion are not overpowering, they are nevertheless significant.

With this in mind, we need to understand the effect color bias can have on our overall perception of a photograph. Listed below are several widely used color-transparency films, and the generally accepted bias imparted by each. Although more pronounced a decade ago, these differences still exist and are especially visible under less than ideal lighting conditions.

Kodachrome: a definite yellow (warm) bias
Ektachrome: a blue (cool) bias
Agfachrome: a pronounced yellow bias, even warmer than Kodachrome
Fujichrome: almost chromatically neutral—little, if any, bias

Obviously, the choice of film type is important in setting or at least reinforcing a mood. Kodachrome, for example, produces ruddy, healthy skin tones that are pleasing though not necessarily accurate. As we pointed out in an earlier exercise, there is no perfect color reproduction but only a psychologically acceptable color rendition. Understanding the properties of color film can allow us to make subtle adjustments to overall color impact. For example, if we wish to tone down prevailing color casts, we should know that Kodachrome can warm up an otherwise cool and overcast scene; Ektachrome can cool down the excessive warmth in late-afternoon sunlit scenes. Thus, thoughtful selection of transparency material can contribute to the mood intended.

Filtration

Thus far we have dealt with relatively subtle color manipulation through film choice. Larger shifts in color emphasis are possible through the use of filtration either during picture taking or in the darkroom. Most photographers who use filters to alter the overall color bias of an image use two basic types—the 80 series, which has a pronounced cooling effect, and the 85 series, which has an opposite, warming effect. When we use filters to affect large color shifts, everything in the resulting photograph will take on the filter's color. Problems can arise, for color film and color filters can dominate a photo to the point where content cannot compete with color for viewer attention. Scenes containing strong lines, shapes, and forms can be supported quite well by adding overall color filtration. Backlit scenes (where silhouettes are desired) can also benefit from a monochrome color treatment. The warning we add is that especially dramatic shifts in color through filtration can easily become visual clichés. Use them thoughtfully.

1. Using the chart on page 86, describe ten scenes you would typically photograph.

2. Go into the field and check your perceptions by photographing the ten scenes as planned in the chart.

3. For two or three scenes revise the procedure and apply the opposite color modification. Study the results.

4. Experiment with color films and filters until you feel confident using them.

5. Study magazine or book illustrations. Determine to what extent the overall color of an illustration contributes to its effectiveness. Would you have chosen a different color? Why or why not?

Scene Description	Mood Intended	Mood Enhancer (film/filter)	Other Visual Modifiers

Color versus
Black and White

The age-old question of whether to photograph a subject in color or in black and white has no ready answer. Photographers and critics have argued for decades for the use of each. Still no one has discovered a pat formula that seems to satisfy the photo world. To explore this issue, we present a case for both black and white and color.

The Case for Black and White

This usually takes two forms:

1. Arguments extolling the virtues of black-and-white photography

2. Criticism of color photography

Black and white is by its very nature an abstraction and thus ideal as a vehicle for interpretive image making. Enthusiasts point to the inherent pictorial qualities of black and white that allow the photographer to emphasize pure form, line, texture, and tone. They argue that when these qualities are of prime importance, black and white is the only choice. Beyond this, they suggest that black and white has been the only photographic material taken seriously as "art."

Those who favor black and white disparage color as a mere gimmick. They imply that color dominates the photograph at the expense of content—in other words, that color obscures meaning. They argue, further, that color makes photography too explicit—photographs become mere replications of reality rather than personal interpretations.

In addition, supporters of black and white believe that it spurs creativity and innovation expressly because there is no color to lean on. In other words, it is more difficult to produce an outstanding photograph in black and white.

The Case for Color

Color enthusiasts, on the other hand, believe that color brings photography alive. Color photographic images reach out and touch us in a very personal, intimate way. Of all the visual communications media color photography is the most real. Black and white, they claim, is sterile, analytical, and aloof. Color does deal with tone, line, form, and texture and does so better because of the added dimension of color. Last, the color adherents point to the billions of color photographs taken each year and ask, Can this many people be wrong?

Both positions contain grains of truth, although each is perhaps overstated and misrepresented. The first point to consider is that photographs are great because they live over time. Their appeal lies in the sense of wonder, excitement, anger, surprise, and so on that they evoke. Simply because a photograph is rendered in black and white or color is not the issue. Neither has a monopoly on truth. And truth is the quality that creates memorable images. We believe (and this is what we ask you to test) that black and white and color have different expressive potentials. The unique properties of each demand their use under given circumstances. In other words, each has its place as an expressive tool. The issue is not whether black and white is better than color but how well each can be employed to express the photographer's intent. Your task in the following exercise is to decide when the expressive properties of each can be used to best advantage.

exercises

1. Choose several subjects of widely different shapes, tones, and textures. Include animate and inanimate objects.

2. Take photographs of each subject in both black and white and color.

3. For two or three subjects, select *either* black and white *or* color and photograph them.

4. Draw up a list of 30 subjects or scenes around your neighborhood. Now divide this list into three separate ones—those subjects you feel would be better photographed in

 a. Color only

 b. Black and white

 c. Either black and white or color

5. Evaluation:

 a. Examine the photographs of the subjects produced in both black and white and color.

 (1) Can you choose the more effective medium for each?

 (2) What criteria do you use to make the choice?

 (3) Are the qualities inherent in black and white or color critical to the effect of your image? To what extent?

 b. For the subjects for which you made a deliberate choice of either black and white or color, can you state why you made the choice? Did it work? If so, how?

 c. Concerning the subjects that you decided could be photographed in either black and white or color, what did you see that led to this conclusion?

The Effects of Color on Viewer Perception

Individual colors project quite specific meanings. However, the overall color emphasis a photograph projects can do far more to influence viewer perception than any one color. Thus, color can give an image an overall feel much the same as the tonal relationship does in a black-and-white photograph.

As we saw in the last module, many black-and-white purists reject color as a key ingredient in the creative mix, viewing it only as a gimmick that masks inferior photographs. But because color is here to stay, it seems logical to understand its potential as a creative tool even if we choose not to use it. We feel there is overwhelming evidence that color is a potent persuader. Examining the work of contemporary advertising and fashion photographers is quite revealing in this regard. These photographers use color to manipulate our perceptions, creating an emotional climate conducive to our positive acceptance of the client's product or idea. For them, color is a critical component in what is essentially a rhetorical situation. Advertisers have learned that subtle changes in overall hue, tint, or shade can often result in disproportionate shifts in image emphasis and meaning.

For a fuller understanding of color we need to realize that the color we see is different from the color recorded on film. The qualities we see (chroma, tint, shade) define the relative importance of a color perceptually. Color may be subdued and quiet, alive and energetic, or anywhere in between.

The task we set for you is twofold: to understand how color is recorded on film and how color alters our perceptions of the subject.

exercises

1. Examine a number of magazine, billboard, and television ads. How is color being used to evoke sensation?

2. Illustrate how color can be used to show the same types of relationships that tonal variation does in black-and-white photography.

3. Research color theory in the works by Hedgecoe, Bailey and Holloway, Zakia (*Color Primer I and II*), and Isert listed in the bibliography. From your reading

 a. Define color harmony and color dissonance. How would you expect viewers to react to photographs featuring color harmony? Color dissonance?

 b. Define color chroma, tint, and shade. What is meant by adjacent color? Complementary color?

 c. What are the basic rules offered for the use of color? Do you agree with them? Why or why not?

 d. Defend or refute the following statement: Color photography is the refuge of the visually unsophisticated.

 e. Cite examples where color has taken on political, religious, or social significance. What ideas are associated with colors?

twenty-six

Masters of Color

Over the past 25 years color photography has boomed. This growth can be attributed to strides in color-emulsion technology, mechanical and electronic innovation in camera systems, and increased automation in color processing. Now, millions of novice photographers routinely shoot color and produce billions of quality photographs. However, few tap the true expressive potential of color in their images. A handful of photographers have seized the opportunity and utilized color in ways that set their images apart. This module is devoted to four photographers who are recognized as masters of color. For them, color is not just another tool but rather the dominant visual force in photography.

Joel Meyerwitz

Joel Meyerwitz earned his reputation in photography largely through his spontaneously produced black-and-white images of urban streets and their people. Later, he began to appreciate color while experimenting with large-format view cameras. Rather than seek out Cartier-Bresson's "decisive moment," Meyerwitz began to practice a studied, contemplative approach to his subject. For some, Meyerwitz's work is evidence that color, subtly employed, can be inherently more expressive and versatile than black and white. He and other color-film users assert that its use increases the amount and variety of visual information that can be recorded. Once recorded, they argue, color information forms the basis for a wider range of creative options. Minor adjustments in printing routinely produce perceptible shifts in color gradation or emphasis,

altering the visual quality of an image to a much greater extent than corresponding adjustments would in black-and-white printing.

Even though Meyerwitz attempts, as he phrases it, "to capture my feelings before the subject," he revisualizes the subject in the darkroom. There, he refines and hones his first impressions and even discovers new and exciting images.

Because Meyerwitz chooses to use an antiquated view camera, his technical options are limited. However, because he is not bogged down with technical considerations, he finds himself better able to respond to the qualities inherent in the subject. Many of today's photographers, using very sophisticated equipment, are faced with a burden of riches. With so many possibilities and options, it is possible to lose sight of, figuratively and literally, the meaning of the subject. To Meyerwitz, simplicity leads to intimacy with his subject. He can concentrate on and understand what he feels and wishes to express. Leafing through his book of color photographs, *Cape Light*, we can appreciate his ability to find the proper visual forum in which to share his feelings with us.

Pete Turner

Unlike Meyerwitz, Pete Turner admits to being a consummate image-*maker*. Even so, he points out that the almost always begins an assignment by studying the subject as it presents itself, attempting to understand how he feels about it. Using 35mm SLRs and Kodachrome transparency film, Turner works in creative stages. The original transparency is nothing more than a place to begin. Employing slide duplication and filtration extensively, he transforms the original slide into his vision of the subject.

The color in a Turner image is deeply saturated and vivid. Turner reduces visual information to the simplest form necessary to convey the desired impression. He emphasizes shape and pattern, reinforced by bold, strong color. The graphic quality of his work, which is not unlike posters and silkscreens, makes his images all but impossible to ignore. They have what Andreas Feininger calls stopping power.

For Turner color and form are totally subjective, and his use of unconventional, surprising color combinations gives added visual immediacy to ordinary objects. Although lacking great depth and detail, a typical Turner print exhibits his extraordinary ability to manipulate color and form so as to underscore the symbolic qualities of his subjects.

Ernst Haas

A free spirit, Ernst Haas has for decades been an acknowledged leader in the innovative use of color. Color is so integral to his visual orientation that it becomes a central force around which other picture elements—exposure, composition, and perspective—revolve.

Early in his career, because he was forced to use slow color film and slow shutter speeds, he became fascinated with color-motion relationships. He learned to exploit the blurring and mixing of colors, evolving what we now recognize as the distinctive Haas style.

Haas has added a new dimension to the philosophy of seeing. When he begins a photographic session he rarely knows where he is going or what is going to happen. He strives to be constantly surprised by what he discovers. For Haas, it is *discovery* that makes

photography so exciting. His constant search for the unconventional has allowed Haas to break new visual ground. Not content to freeze action as a representational rendering of the subject, Haas emphasizes motion by consciously manipulating color. Through his distinctive approach to color Haas seeks to capture the essence of motion with all its energy and tension.

Philosophically, he rejects strict adherence to any one set of rules. Instead, he offers some sage advice of his own. Here is a sample:

On color: We all have a color key. Each of us expresses a color preference by the way we dress, the color of the objects we surround ourselves with, and the colors that dominate our photographs. For most of us, the color key is subliminal and must be discovered.

On composition: Most composition is intuitive. We all have a compositional key: We are attracted to certain physical combinations or arrangements. Things in threes, triangles, and curved lines are examples of compositional keys. Like the color key, the key is not necessarily apparent; we must search it out in our images.

On diagonals: Diagonals are dynamic and give depth and flow to our images. For Haas, diagonals have a lyrical quality.

On seeing: There is a difference between seeing and simply orienting. Most often we merely orient ourselves to our surroundings; we don't truly understand the physical world around us.

Ernst Haas has found the world to be a feast of motion and color. His philosophy is best summed up in one of his aphorisms: "The more you look, the more you can find." He has never stopped looking and finding, for himself and for us.

Eliot Porter

For a number of years the images of Eliot Porter have been a rallying point for conservationists as they attempt to preserve the precarious balance of nature in America's woodlands and parks. To many, Porter's depiction of nature is color photography at its best. What makes his images so memorable?

Part of the answer has to be his sensitivity and affection for his subject. But beyond this, he is first and foremost a consummate craftsman. A product of the f64 school of intimate seeing, he offers us exceptionally clear, richly detailed images exhibiting uniform sharpness throughout the photograph. Porter's photographs are a feast of shape, texture, light, and color, yet they do not seem busy or cluttered. It's as if we are seeing firsthand.

Porter accomplishes his first by selecting a portion of the vast landscape to represent his impression of the whole. Second, he rarely includes horizon lines, thereby visually persuading us to examine the lush detail he has photographed. Finally, he doesn't overwhelm us with color. He uses color delicately, as an accomplished watercolorist would. Many Porter photographs feature monochromatic color. They highlight natural order in various shades and tints of one particular hue. Others stress the harmony of only two or three colors. Porter's colors never seem false. There is a sense of correctness about them, natural in their proper place and intensity.

A patient worker, Porter might spend hours studying one scene before actually photographing it. He is equally painstaking when it comes to reproduction. He employs costly and time-consuming color-separation techniques to produce photographs of exceptional clarity and quality. In sum, one could say Eliot Porter's approach is wholistic—totally integrated from initial conception to final print.

exercises

1. Assume you have a manual camera with limited f-stops (f5.6 to f16) and shutter speeds (1/30 to 1/125 sec.). Shoot a series of photographs that turn these apparent limitations into advantages.

2. How does the Meyerwitz approach differ from that of Pete Turner and Ernst Haas? Are there any points of similarity? How is Porter's use of color different from theirs?

3. Choose a subject and shoot a series of photographs in which you emulate the style of each of the four photographers discussed in this module. Which photographic styles were you most at ease with? With which did you have the most difficulty? Why? List five possible image concepts best treated by utilizing the style of each of the four photographers.

4. Select a transparency and project it normally. Then project the slide in reverse.

 a. Of the two projections, which seems most correct?

 b. What is it about the unnatural projection that bothers you?

 c. What does this experience tell you about the relationship between composition and intuition?

5. Shoot one or a series of photographs that represent your concept of color as subject.

6. Comment on the following construct:

Initial visual attraction	=	Thesis
Defining what you see	=	Antithesis
Resulting image	=	Synthesis
Evaluation of image	=	New thesis

7. Why has it been difficult to establish color photography as a legitimate art form, both within the photographic establishment and in the art world generally? (Refer to Module 24. You may want to do some additional research in order to come to a well-reasoned answer to this question.)

Introduction to Visual Modifiers

Seeing in the sense we discuss it in this book is a twofold experience. It is, first, sensitivity to the qualities of the subject. But sensitivity does little good without the second part of the experience—translating what we see onto film and thereby communicating it to the viewer. The problem is that the human eye sees quite differently than the camera lens. The human optical system receives and transmits objective reality, but what the brain perceives is subjective. That is, the brain manipulates visual messages in a number of ways and distills a subjective meaning. Cameras, however, "see" what is physically present and record on film without judgment or interpretation. Only we make judgments or interpretations. We need to understand how a camera sees, so that we can modify that vision when it suits our expressive purposes. We also need to integrate our knowledge of the tools into a total decision-making process.

Many decisions and choices flow from our initial awareness of the subject through our formation of the residual message (see the chart that follows this Module); others are dictated by the peculiarities and limitations of the photographic process itself. For example, we know a photograph is basically a two-dimensional representation of a three-dimensional subject. Because the medium is two-dimensional we are left to create the illusion of depth by changing the way the camera records the image on film. Without conscious effort on our part, any feeling of depth will be purely a matter of chance. We have a choice: either to exert control or to trust to luck. In addition to our understanding our intent, control depends on mastery of the *visual modifiers*—the means of keying the viewer to the important or unusual qualities of a subject. Understanding and using them effectively will allow us to free the image locked in our mind and faithfully reproduce it on film.

Study the chart that follows. Notice how many times judgment comes into play, contrary to camera makers' claims that picture taking is automatic. Each of the eight visual modifiers in the chart has a specific application, but combinations of two or more are often used to enhance an effect.

Thinking Photographically: A Flow Chart

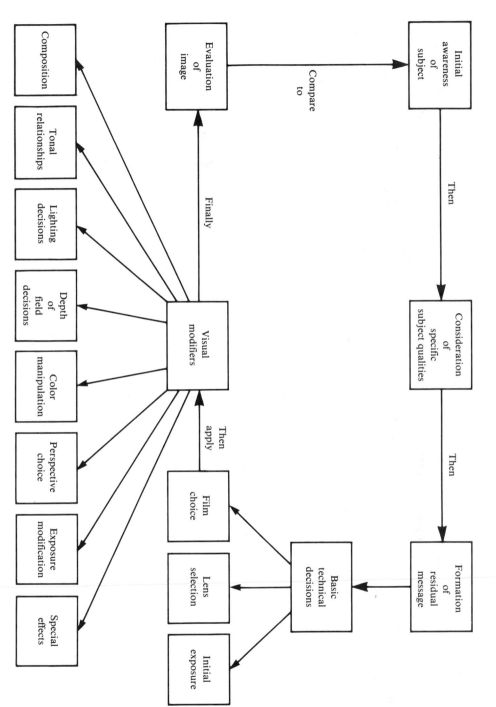

Establishing a Personal Viewpoint

Viewpoint, or perspective, has been defined as a system of visual organization in which the photographer represents three-dimensional objects on a two-dimensional surface so as to give a realistic impression of depth. This definition is valid but does not go far enough. One's choice of a particular perspective can change, emphasize, and/or enhance the specific qualities of a subject. It can also alter the relationship among objects within the scene. Choosing a particular perspective can force viewers' attention to one part of the scene while deemphasizing another. The viewpoint you choose represents your individual response to a picture-taking event and helps make each of your photographs a personal statement.

Camera Position

Photographs are normally taken at eye or waist level, depending on camera type. We are constantly admonished to line up the vertical and horizontal lines in the subject so that they parallel the sides, top, and bottom of the viewfinder frame. It's what is expected. Herein lies the problem: If we assume conventional perspective for all our photographs, don't we forego opportunities to see from new and potentially exciting points of view? Don't we miss opportunities to surprise and excite our viewers? Of course we do! If you see verticals as verticals, go ahead and picture them that way. But also explore alternative camera positions before pressing the shutter release. Don't overlook diagonals, high angles, or other perspectives simply because they at first seem incorrect or awkward.

Focal Length

As we will see in Module 31, choice of focal length affects the impression of depth in a photograph. From the same shooting position wide-angle lenses seem to separate objects front to rear. Telephoto lenses do the opposite: They compress the *apparent* space between objects foreground to background as seen in a photograph. The impression generated from a scene photographed with a wide-angle lens can be quite different from one photographed with a telephoto lens. The result is that our perception is altered by relatively simple changes in focal length.

The Horizon and Landscapes

The mood of a landscape is often set by the position of the horizon line. A simple repositioning of this line produces surprising changes in the overall theme or emphasis of a photograph. In the exercises that follow you will have a chance to explore the power of horizon-line placement.

Classic Perspective

There are at least two main forms of classic perspective. One is the familiar *aerial perspective*, wherein distant parts of a landscape appear lighter in tone and/or color than foreground objects. Fog, atmospheric haze, drizzle, or dust greatly accentuate aerial perspective, resulting in pronounced separation between foreground and background. Many successful landscape photographers seek out these conditions and lead the viewer's eye through different intensities to the horizon line.

A second type of classic perspective is *single-point* or *linear perspective*. This type of perspective is based on the fact that apparent size diminishes with distance. We can see one of the most common forms of linear perspective by following parallel lines in a scene. As the parallel lines recede into the distance they appear to grow closer until, if unobstructed, they merge into what is called the vanishing point. Linear perspective can be a powerful visual tool, because the eye of the viewer tends to follow converging parallel lines until they reach the vanishing point unless they change direction abruptly or are interrupted by another visual element. The viewer's perception of space does not necessarily end at the vanishing point. Implying space beyond the vanishing point can increase the viewer's perception of depth and volume in a photograph.

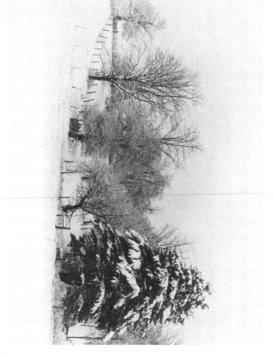

Marc Levey

Aerial perspective can give the viewer a sense of depth.

In summary, consider four relatively simple methods for altering perspective:

1. In the camera viewfinder, select images that are normally seen as horizontal and examine them as if they were vertical. Conversely, examine typically vertical scenes as if they were horizontal.

2. Reposition the image in the viewfinder so that the main subject is off center or near the edge of the frame.

3. Alter camera position in relation to the principal light source. Move around, under, or above the subject until light striking it gives the desired effect.

4. Alter camera position in relation to the subject. Select an alternative to conventional eye- or waist-level viewing. High, low, or oblique angles can generate visual energy or tension not present when the photographer uses conventional perspective.

Perspective choice is only one of many decisions you will have to make in executing a photograph. As with all other visual modifiers, perspective can become too important visually. The most effective perspective is the one that seems to support the theme of the image without itself becoming subject matter.

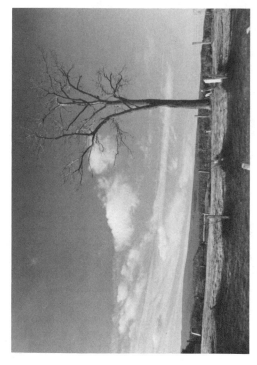

Jim Lloyd

The clouds reinforce the horizontal lines in this image.

exercises

1. Select a landscape scene and photograph it after

 a. Placing the horizon line at about the midpoint in the viewfinder

 b. Placing the horizon line in the bottom third of the view-finder

 c. Placing the horizon line in the top third of the viewfinder

 d. Selecting a viewpoint that eliminates the horizon line completely

 Examine the resulting photographs. What does each emphasize? What is different about each of the photographs? Does the different placement of the horizon in these four photographs give each a different mood? Can you draw any generalizations about horizon-line placement?

2. Find and photograph scenes that illustrate aerial and linear perspective. Illustrate the visual impact of the vanishing point.

3. Select a scene and examine it from a number of perspectives—head on, obliquely, high, and low. Select the one perspective that suits the character of the subject. Photograph the subject from this and one or two other perspectives. Analyze the results.

4. Illustrate the effects of focal length on both depth of field and the physical relationship of objects in a scene. What is the relationship between foreground and background objects when you use different focal lengths?

twenty-nine

Light as a Visual Modifier

Light is essential to photography, yet most of us take it for granted. We know little about how it behaves and consequently fail to appreciate its capacity to alter what we see in a photograph.

Some Simple Physics

What we call light is nothing more than billions of vibrating photons of electromagnetic energy. The light we can see constitutes only a tiny fraction of the total electromagnetic spectrum. Our eyes respond to reflected light waves formed on the retina and transmitted to the brain by the optic nerve.

Characteristics of Light

Other than color, light has two physical characteristics: intensity and direction. A fourth characteristic, light quality, is not physically measurable in the sense of the first three; we judge light quality subjectively.

Intensity

Intensity refers to light's brightness or strength. High-intensity light allows us to use fast shutter speeds and small f-stops even with slow film. When we strive for graphic interpretations emphasizing differences in shapes or mass and are not too concerned about subtleties of shadow or highlight, high-intensity light works quite well.

Low-intensity (low-key) lighting can have a dramatic effect, casting important visual elements in a mysterious veil. Low-key lighting can be visually stimulating because it challenges the viewer to fill in elements of the subject that are lost in shadow. The effective use of low-key lighting rests in offering just enough image detail for the viewer to make visual closure. Too much or too little visual information and the effect is ruined. In Module 2 we examined the phenomenon of visual closure in some detail.

Direction

The direction from which the subject is lit influences how we perceive it in a number of ways. Let's consider the effects of light from three different directions.

1. *Frontlighting.* When lit from the front, a subject can appear flattened and devoid of depth and detail. Contrast is reduced. This is particularly true of diffused frontlighting.

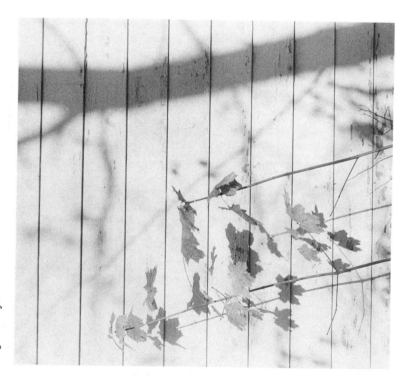

Norman Lowdowski

Direct light casts distinct shadows that can add dimension to the image.

Quality

We define light quality by the degree to which light is or is not diffused. Diffused light generally results in a more gradual transition of tones from highlights to shadows than is the case with direct light. Images appear more delicate and fragile in this type of lighting, which allows subtleties of tone, color, and texture to predominate. Extremely diffused subjects can acquire an almost dreamlike quality. Whether to choose direct or diffused light is determined largely by the impression one wishes to communicate. But be careful that the lighting effect itself doesn't dominate the image at the expense of content.

exercises

We have examined three basic properties of light—intensity, direction, and quality. Along with color, they give us a fuller understanding of the vital importance of light in photography. This seven-part exercise should help you develop a greater awareness of the nuances of light and its ability to modify images.

1. List as many adjectives as you can think of that describe the following light conditions:

a. High intensity
b. Low intensity
c. Direct light
d. Diffused light
e. Front light
f. Back light
g. Side light
h. Extreme side light

2. *Side lighting.* Side lighting emphasizes subject depth to a much greater degree than frontlighting. Light that is 15° to 45° from the front of the subject is called classic side lighting. Forty-five-degree side lighting results in effective modeling of subject contours. Careful observation of this classic lighting pattern demonstrates how light can bend over and around curved surfaces to illuminate the portions of a subject away from the light source. Typical subjects that benefit from this type of side lighting are head-and-shoulder portraits, nature scenes, and still lifes.

At more acute angles, from 45° to 90°, contrast increases dramatically. At 90° the effect is extreme. Lighting from this angle is often termed hatchet lighting because it renders half of the subject fully lit and half in deep shadow. Admittedly, hatchet lighting has few practical applications in everyday photography. But when used selectively, it can have a pronounced influence on the mood created in portrait studies and graphic still-life interpretations.

3. *Backlighting.* Shooting against the light, which is known to photographers as backlighting or *contre-jour* lighting, measurably increases subject contrast, lessens or eliminates detail, and reduces many subjects to studies of form and shape. Silhouette effects are obtainable under backlighting conditions. Extreme care is necessary when metering a backlit scene in which a silhouette effect is not desired. Because of the strong background illumination, most meters will tend to greatly underexpose the main subject.

2. Observe each of the light conditions above in several scenes. Describe how each modifies the way we see the scene.

3. For each type of lighting listed in part 1 of the exercise, list at least three subjects you feel would benefit from it. For certain subjects, you may want to use specific lighting combinations (for example, low-intensity, diffused side lighting; high-intensity, direct, extreme side lighting).

4. How does a light source positioned above or below the subject render it differently than the same light source placed near the horizontal plane of the subject?

5. Evaluate how the qualities of light have differing effects on photographic subjects. Choose at least ten different subjects, indoors and out, static and moving. Shoot a series of ten pairs of photographs. For each pair, shoot one with standard lighting and another with alternative lighting chosen to achieve either the same or a different effect.

6. Photograph one portrait and one still life using *contre-jour* lighting. Choose subjects that you feel are particularly well suited to this type of lighting and explain why they are appropriate.

thirty

Exposure as a Visual Modifier

Exposure is a much discussed and little understood component of photography. In an era of "camera as robot" (to borrow from the ad campaign of a major camera manufacturer), many novice photographers simply turn the problem of exposure over to the camera's automatic system. They believe the camera will set the correct exposure "no matter how tough the light" (to borrow from another ad campaign). Let's set the record straight.

All exposure meters do exactly the same thing. They simply indicate the amount of light available for making photographs. Further, every meter, whether hand-held or in-camera, assumes that all subjects reflect an average amount of light. This average amount has been given many names; *middle gray, median value,* and *average brightness* are but a few. For example, a large expanse of grass lit by the late-morning or noon sun closely approximates a subject of average brightness. Virtually any meter will give an acceptable exposure recommendation for such a scene.

However, most of us do not want to specialize only in photographs of grass. So, although meters provide good exposure information over a wide range of picture-taking situations, in many cases the indicated meter exposure will not result in the desired tonal relationship. Even worse, accepting a straight meter reading can sometimes result in a complete loss of important content in shadow or highlight areas.

Using a Neutral–Density Gray Card

If you are working rapidly or in color, a neutral-density gray card can be a valuable tool for achieving consistently accurate average exposure. You can use the gray card to make substitute readings by placing it in the approximate position of the subject and metering light reflected from the card. Make sure that the same light falling on the subject also falls on the gray card. Except when important content lies in extreme highlight or shadow areas, the gray-card reading should give a very high percentage of usable exposure combinations. You can fine-tune a gray-card reading by adjusting the resulting exposure recommendation up and down the brightness scale. Less exposure emphasizes shadow areas; more exposure emphasizes highlights.

If you don't have a gray card handy, you can still make substitute readings. Use the palm of your hand in place of the card and meter the light reflected from it. Be aware, however, that Caucasian skin usually reflects about one stop more light than a gray card; black skin reflects about one stop less. So, after taking a reading from the palm of your hand, open up one f-stop for Caucasian skin and close down one stop for black skin.

Applying Brightness Range to Exposure Control

Coupled with the problem of the single-mindedness of exposure meters is the disparity between the brightness-accommodation range of photographic film and that of human vision. Our eyes can accommodate a far greater range of brightness than can any film. Typically, we can discern detail in the brightest highlights and the deepest shadows over a brightness range of 100:1 or greater. In comparison, most black-and-white films can record detail only over a 7:1 brightness range; color film records detail over a 5:1 range. But this apparent limitation can be turned to an advantage. For example, if the important content resides in a shadow area of a scene having a brightness ratio of 9:1, we know the film cannot record the scene as we see it. We may very well lose important detail if we follow the meter recommendation slavishly. The key to creatively metering such a scene lies in knowing two things:

1. Which portion or portions of the scene contain important content

2. How you wish each portion of the scene to appear in the final photograph

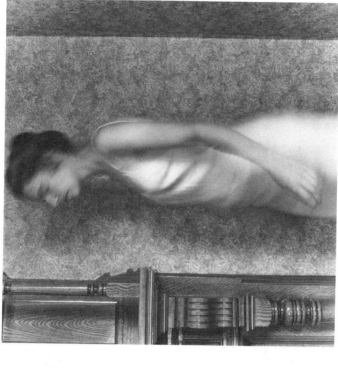

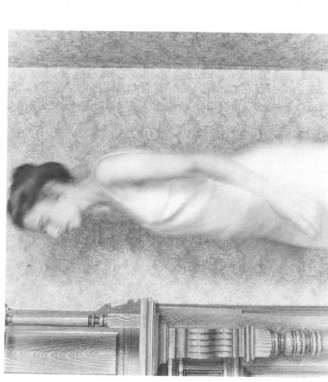

Jennifer Anne Tucker

The mood of an image can be altered by changes in exposure in the camera or in the darkroom.

What we call the residual message the famous pictorialist Ansel Adams termed *previsualization*. Adams developed a method—applicable primarily to black-and-white photography—of pre-visualizing and adjusting exposure and film development and thereby enabling photographers to represent tones in any scene as they wish them to appear in the final print. Called the zone system, the Adams methodology has been widely accepted as the standard reference for exposure control. (For more about the zone system, refer to the books by Davis and White, Zakia, and Lorenz listed in the bibliography.) Although you can alter the appearance of the photographic print by varying film-development time, using different paper grades, or applying a number of other controls, the task of producing a print as you wish it to appear is far easier if you have exposed the film effectively in the first place.

exercises

1. Choose an outdoor scene, meter it as you normally would, and note the exposure. Study the tonal relationships of the scene. Judge whether the scene is one of average brightness that you could photograph at the meter reading you took. If not, how would you modify the exposure? Note your adjusted exposure. Next, take a gray-card reading and compare it with the original meter reading and your adjusted exposure. If there is a measurable difference among the three exposure readings (original, modified, and gray-card), take one photograph at each reading. Study the results.

a. Which exposure was most faithful to the original scene?
b. Which fulfilled your expressive intent?
c. How did exposure manipulation fulfill your intent?

Repeat the exercise in different lighting conditions.

2. Select a subject lit by flat, even lighting. (Open shade and an overcast day provide good examples of this type of lighting.)

a. Meter as you normally would and photograph the scene.
b. Take two additional photographs, one in which you increase the exposure by one f-stop and the other in which you decrease it by one f-stop.

Examine the resulting photographs. Does a one—f-stop adjustment to the indicated exposure make much difference in the overall effect of the image? If so, how?

3. Select a subject having a high brightness ratio.

a. Using your light meter, devise a method for determining the brightness ratio.
b. If the ratio exceeds the brightness range of the film, determine which end of the brightness scale contains the most important content. Meter the selected area, and use a series of exposures to give a range of pictorial renditions. Examine the resulting photographs carefully. Determine which exposure modification produced the photograph most representative of your intent.
c. Repeat this exercise several times—but shoot only one exposure for each situation—until you become proficient at prejudging exposure modification. Don't be surprised if you use up a few rolls of film. Be patient and concentrate.

4. Load your camera with a roll of color-slide film. Remember that the exposure you choose has a decided effect on the overall feeling an image projects. With this in mind, make a number of exposures

a. At the meter setting
b. At the modified setting
c. At a setting opposite the modified setting

5. Consider all the preceding experimentation with exposure control and modification.

 a. What did you discover about calculating a brightness ratio? What is the relationship between f-stop and brightness ratio? What impression do you expect from a low-brightness-ratio black-and-white print? A high-ratio print? Which is likely to be more dramatic? Which more subdued?

 b. When adjusting exposure, did you tend to overcorrect or undercorrect?

 c. What advantage is there in biasing exposure for shadows or highlights? How can biasing exposure help the viewer understand your intent more precisely?

thirty-one

The Illusion of Depth

Depth is normally thought of as a physical phenomenon. But depth also has a psychological component. Obviously, in a two-dimensional image depth can only be implied. No matter how much depth is available physically, its impact is determined by the way it is implied.

Depth of field is physically determined by three variables: aperture, focal length, and film plane to subject distance. Knowing these three variables, one can compute an area within which a subject will be rendered with acceptable sharpness. Depth-of-field tables have been computed for this purpose, and most lenses have a depth-of-field scale on their barrel. In addition, many SLRs have depth-of-field preview capabilities that allow the photographer to see the area of sharp focus before taking the picture.

Kathleen M. Langston

Very shallow depth of field draws attention to the sharply focused subject.

Lens choice has a profound effect not only on the depth of field that can be encompassed in an image but also on the overall impression of depth. Telephoto lenses appear to flatten and compress images from front to rear. Wide-angle lenses seem to add body to objects in their field of view.

Depth is desirable in many photographic situations, but we hasten to add a note of caution. Perceptual psychologists have demonstrated that viewers fix on sharply focused rather than unsharp picture elements. Photographs containing great depth and equally sharp planes of focus present problems for them. It's important to offer viewers a focal point. By using color, composition that guides the eye, unusual perspective, and so forth, we can preserve the illusion of depth while still guiding the viewer to important content.

exercises

1. Select an outdoor scene that includes several objects at different planes from front to rear. Good lighting is essential so that you can choose a variety of f-stop/shutter-speed combinations.

 a. Place the camera on a tripod and set it for the smallest f-stop possible. Take three photographs, focusing

 (1) On the front third of the scene

 (2) About midway into the scene

 (3) At infinity

 b. Open the lens as wide as possible and repeat step A. Examine the resulting images. What differences other than overall sharpness do you notice? Is there any difference in overall emphasis? Which of the images, if any, portrays the scene as you saw it?

2. Select a portrait subject. Focus on the subject's face and take three photographs, selecting

 a. The smallest f-stop available

 b. A medium f-stop

 c. The largest f-stop available

Examine the images. What is the focal point of each? Are there visual problems with any of the images? In which photograph did the camera record what you thought you saw? Why?

3. Select a scene that interests you. Decide on a residual message. Now, control depth of field so that it will support the message. Examine the resulting images and determine whether your choice of depth of field in fact supported the message.

Marc Levey

Controlling depth of field allows us to control what is perceived and what isn't.

4. Photograph several scenes in which you create the illusion of depth by using

a. Color

b. Unusual perspective

c. Directive composition (strong converging lines, for example)

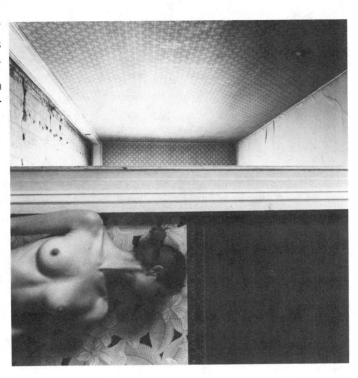

Jennifer Anne Tucker

The photographer titled this photograph "Two-faced Self." Does the great inherent depth support this theme?

Line and Shape
as Visual Modifiers

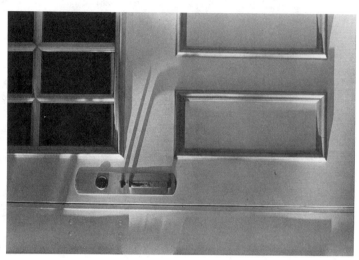

Kathleen M. Langston

Effective organization of line helps direct our seeing.

Line

Lines are generally understood to be continuous tracings connecting one point or object to another and moving in one direction, defining a space. A road leading the eye into the distance is an example of a visual line. Such a line has physical dimensions and can be defined as *real*. However, we see more than real lines. We connect objects to one another with *implied* lines if they are grouped so as to facilitate psychological closure. (See the discussion of the Gestalt laws of closure, proximity, and similarity in module 2.) Lines can therefore be real or implied.

Within these two categories there are many different types of lines. In the literature of perceptual psychology and art design we find numerous theories concerning the psychological effects of lines on our perception. Selected theories are offered here as a reasonable place to begin considering how line influences not only what we see but how we see. These theories are not absolutes but rather the conventional wisdom about line as a visual force. Instead of blindly following a set of rules or laws, we think it is vital to consider the line within the overall context of image meaning and artistic intent.

Keep an open mind as you consider the following discussion of traditional line theory. Then, as you work through the exercises apply the theory not literally (to demonstrate the "correct" use of a line) but appropriately (to enhance or support the communication).

If lines do not add to the viewer's understanding of an image, they have little or no value.

Visual Lines

Horizontal

The most common line, the horizontal, is naturally stable. It conveys a sense of coolness, and as a continuous tracing it implies serenity. Strong horizontal lines, because of their inherent stability, can conflict with the greater vigor and the warmth of a vertical format, suggesting aggression. A series of horizontal lines in a horizontal format tends to separate tones and add depth and expanse to the image.

Vertical Lines

Wassily Kandinsky, the celebrated artist and designer, suggests that vertical lines are warm, solid, and assertive; they imply height while not contributing to any sense of distance in a photograph. More than the stable horizontal line, the visually active vertical line requires our special attention as we examine a potential photographic subject. In a photograph of a subject having both horizontal and vertical lines, such as a skyscraper, the vertical component forces attention to points of intersection.

Diagonal Lines

The most energetic of all lines, diagonals also imply directionality more than any other line. Because most of us are products of a Western culture and "read" a photograph from left to right, we see a diagonal line emanating from the lower left to the upper right as rising. Diagonals emanating from the upper left to the lower right we see as falling.

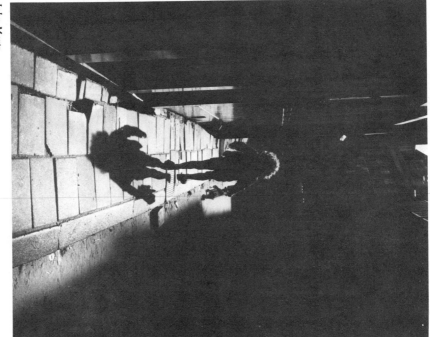

John Mertz

Diagonal lines are visually active.

Movement represented by strong diagonal lines is so vigorous that we must be careful not to lead the viewer's eye off the image. We need another visual force, such as a strong mass, contrast, or color, in order to hold the movement of the diagonal in check. As you study diagonals take special note of the energy and movement they represent.

Curved and S-Shaped Lines: Partial Circles

Curved lines, whether they form a shape or not, are the most restful and natural of lines. Their movement is not nearly as vigorous as that of diagonals. Rather, these lines convey a sense of slow, easy movement that underscores a natural rhythm. We can call them *quiet* or *soft* lines.

Oblique and Random Lines

Oblique, straight lines that form acute angles are difficult for most of us to deal with visually. They tend to unbalance otherwise balanced compositions, symbolizing disorganization and a certain anxiety. As with the strong diagonal, we can tame the visual influence of oblique lines by introducing a countering visual element, such as a strong horizontal, parallel line, or a visual spot (visual spots are discussed below).

Shape and Form

Shape may be defined as line seen wholistically—in other words, as line seen as closed. The same comments we made about line theory can apply to shape and form as well: Although shape and form usually have a complex visual function, we need not follow rules or laws that are supposed to govern their behavior. Again, judge shape and form in an overall context of meaning: Do they enhance or detract from the visual impact or meaning of your image? Like lines, shapes can be either real or implied.

Charles Puckey Jr.

An interesting combination of line, shape, and texture.

Form and flow are emphasized in this image.

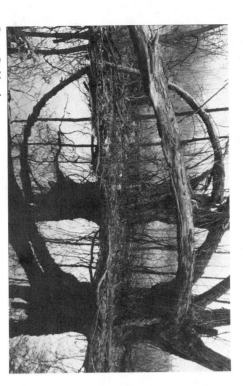

Steven P. Mosch

Basic Shapes

There are five basic shapes. Each conveys meaning differently. Let's examine how they create a mood or feeling.

1. Triangles. The triangle is claimed to be the most active of all shapes. Because their eye is attracted to the triangle's apex, viewers sense strong movement. Also, triangles with a large horizontal base tend to suggest strength and solidity.

2. Squares. True squares are not often observed in nature. An image dominated by a square projects a sense of balance and order. Squares, by their very nature, are not visually active; they are instead restful, almost to the point of being visually inert. If square shapes dominate a composition, another attraction may be needed to hold viewer interest.

3. Rectangles. The most common natural or man-made shape, the rectangle has long been favored as the ideal picture format both by artists and photographers. Rectangles, by their very nature, set up a horizontal-vertical contrast and can thereby imply movement. As the ratio of length to width increases, so does the likelihood of the shape being perceived as a line rather than a rectangle.

4. Circles. Of all shapes, circles seem the most complete and independent. They are aesthetically compelling and signify completeness or containment. When positioned near rectangular or triangular masses, circular shapes soften the overall compositional impression. Circular shapes that enclose objects demand far more visual attention than squares or rectangles.

5. Irregular shapes. Irregular shapes can be roughly divided into two classes—curved and straight. Curved irregular shapes seem to flow, and are accepted as natural and comforting. Straight irregulars are another matter. Formed by straight lines joining at acute angles, they project a straight, discomforting tone. Also, they can confuse the viewer, whose eye is hard pressed to follow acute, abrupt directional changes.

Form

For our purposes, form is defined as shape in three dimensions—that is, shape with depth. Cubes, spheres, pyramids, and parallelograms are common forms. The same rules and laws governing line and shape are generally applied to form.

The Spot

All shapes and forms are potential visual spots. When a shape loses its identity and dominates an image simply because of its location, tone, color, or content, it becomes a visual spot. If a dominating spot is centrally placed, the image seems to rotate around it. When placed near an edge, the spot often pulls the viewer's attention away from the content and off the image entirely. Because they are such powerful attention getters, spots must be used carefully and appropriately and only to support the meaning of the image. A skillfully placed series of spots, even small ones, can help move the viewer's eye through an image in a predictable manner.

exercises

In exercises 1, 2, and 3 you may wish to photograph examples for future reference.

1. Observe how lines define our perceptions of objects. Name several objects that are described in terms of their line.

2. Do your perceptions of shapes follow the rules outlined in our discussion? If not, do you draw other inferences from shapes than the rules would suggest?

3. Locate five visual spots. Do they support or detract from your overall impression of a scene? If you find them distracting, how can they be eliminated or altered?

4. Compositional theorists have suggested that we can create "ideal" images by balancing a large visual shape or form with a smaller one. How do you react to this? Is this kind of balance always desirable? Can you cite instances when it is not?

5. What feelings do you associate with an image that you sense is visually balanced? Imbalanced?

Leslie P. Greenhill F.R.P.S.

An example of natural flow created by s-shapes.

6. In the field, select potential subjects and analyze how lines, shapes or forms, and spots either support or detract from the meaning of an image.

7. Photograph nine separate scenes, three each in which lines, forms or shapes, and spots are visually significant. Evaluate each scene and determine how these significant elements can be best employed to support the theme or message of an image. Study the resulting images. Was your pre-picture-taking analysis reflected in each image? If not, why? Shoot again if necessary.

thirty-three

Pattern as a Visual Modifier

Visual organization is essential for two reasons. First, it helps us understand what we see prior to and during picture taking. Second, a clearly visible organization of symbols can help give viewers a more direct understanding of the photographer's intent. When studying a photograph, most viewers try to find an organizational scheme. It follows, then, that if we wish our audience to understand our images, we would be well advised to design our photographs, as far as practical, around a specific organizational construct. One of these is pattern.

Patterns used solely for their own sake, however, pose problems for us. Physical repetition can be deadly boring by itself, for it does little to generate visual energy. We don't mean to suggest that you strictly avoid regular patterns, for they can create visual expectation and excitement if (1) they are carriers of important visual information, and (2) they can be integrated into the overall theme of a photograph. But if the pattern is too regular and predictable, we risk diluting the visual impact. Therefore, we advocate a certain stylized redundancy whenever regular pattern is regarded as an important visual element. By all means seek out patterns, but look for stylizing elements such as texture, form, color, or light that add visual dimension to an otherwise straightforward organization. In addition, you may wish to explore seemingly disjointed patterns that create tensions, aggressions, and anxieties, if these are the qualities you wish to express.

Patterns have a role to play as visual modifiers provided they support the ideas or mood inherent in the photograph. Most photography writers tell their readers that they should first seek out regular patterns as a means of organizing what they see. But we are not so sure that pattern alone will suffice for this. Pattern is unquestionably a viable means of organizing what we see, but it can lull the senses if too regular and predictable.

exercises

1. Locate and photograph scenes containing the following patterns:

 a. Strict repetition

 b. A naturally occurring pattern

 c. A man-made pattern

 d. A pattern formed by reflection

 e. A pattern formed by light and shadow

 f. A human pattern—face or form

 g. A pattern that conveys rhythm or flow

 h. A harmonious pattern

 i. A discordant pattern

 j. A pattern created by color

 k. A pattern destroyed by color

 l. Multiple patterns in a scene

2. Photograph a scene containing a regular visual pattern. Then either add something to the pattern or integrate it with other visual modifiers and photograph the scene again. Study the resulting photographs. Develop a rationale for why you altered the original scene the way you did.

3. In your living room or dorm, observe and list as many patterns as you can. Compare your list with those of others, if possible. What kinds of patterns do you see most often? What does this tell you about the way you see and organize the physical world?

4. Use pattern to bring attention to subject matter in a scene, and then photograph the scene. Describe how you used pattern to do this.

5. Does color affect how we see pattern? If so, how? Photograph scenes you think represent the effective use of color to form pattern. Photograph a scene in which color interferes with pattern recognition.

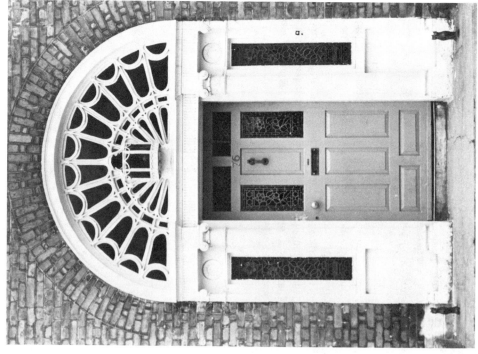

Marc Levey

Repeating patterns can provide an interesting visual experience.

Texture
as a Visual Modifier

Texture is the surface quality of an object. We learn much about the physical world around us from tactile experiences as we explore or randomly come into contact with the surfaces, coverings, skins, and shells of all manner of objects. Even so, we tend to overlook texture in everyday activity. But still photographers cannot be so casual about texture, for it plays a vital role in communicating significant visual information to the viewer. We can dramatically alter meaning simply by emphasizing or deemphasizing texture.

We make the following generalizations concerning texture:

1. Most photographers are quite insensitive to the potential of texture as a visual modifier.

2. Modern photographic equipment and materials enhance the textural qualities of a subject.

3. Emphasizing the textural quality of a subject contributes much to bringing it "alive."

William Besecker

Trinette Harnish

Side light brings out the textural qualities of many subjects.

4. Lighting is the key to how texture will be seen.

5. Texture can contribute to the illusion of depth in a photograph.

6. Texture in a still photograph is an illusion.

Rather than discussing texture at length, we ask you to experience it for yourself. Sensitize yourself to the role it plays in defining the quality of a subject.

exercises

1. With one photograph each, illustrate your vision of the following textures:

 a. Pockmarked
 b. Slick
 c. Glittering
 d. Craggy
 e. Abrasive
 f. Glossy
 g. Worn
 h. Antique
 i. Coarse

2. Lighting for texture. Choose a subject rich in detail and decide whether texture is an important quality to be emphasized. If it is, plan the lighting so that texture is emphasized. What types of lighting display and heighten texture? Which do not? Illustrate texture as a visual modifier—that is, as a means of keying the viewer to the unusual or important qualities of a subject.

3. Determine how skin texture defines a person's character. Illustrate three different skin textures that contribute to our understanding of a portrait subject.

4. Choose three different objects and photograph them with closeup equipment. Reproduction ratios from 1:5 to 1:1 will suffice. Examine the photographs.

 a. Did texture take on any added significance?
 b. Did texture redefine the subject in any way. If so, how?
 c. Did you discover anything about the subject you didn't see before?

5. Find a subject containing two or more distinct textures. What type of lighting will accentuate differences between the two? How do these differences create visual interest? Photograph the subject so as to feature this textural contrast.

6. After a rain shower, examine the wet pavement. Do you see any textures? Is dry pavement different? If so, how do you account for this? Do reflections create new textures? Illustrate.

7. Spend about 15 minutes studying your immediate surroundings. List as many different textures as you can. Be specific. Which ones appeal to you? Which do not? Try to determine why your eye is attracted to certain textures and rejects others. What is your texture key?

8. Textures as abstract patterns. Examine several textured objects closely. Choose small sections of the objects and seek out interesting patterns, designs interwoven with texture. How many images do you imagine are contained in each object? Photograph as many as you can find.

9. List five textures you can hear.

Photo Presentation
and Display

Most visual artists make presentation an integral part of their creative thinking. For some reason, photographers pay less attention to this part of the creative process. Often this results in indifferent or inappropriate display. There seems to be little logic to the way they choose to mat, mount, frame, and hang their photographs.

A word or two about the psychology of display is in order at this point. In our opinion, matting and framing serve to delineate an environment within which to view an image. When mats and/or frames are seen as objects themselves, the photographic image is in danger of being lost in the visual shuffle. Photo-display decisions need to support rather than compete with the theme of the image. To accomplish this, we try to keep mats and frames as simple and neutral as possible.

We offer the following guidelines for your consideration. As with all things subjective, do not take them as laws but rather as useful generalizations.

Mats

Small prints require a wider mat then large prints. Most photographers agree that a vertical-format print looks well proportioned when matted with top and sides of equal width and the bottom 1.5 times larger. For horizontal prints, the bottom and sides should be

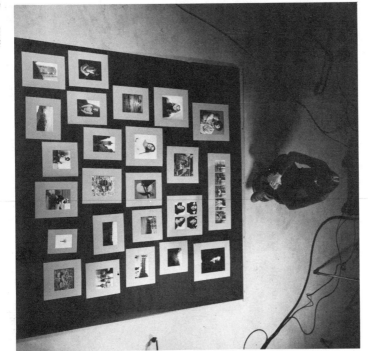

Steve Williams

Now what do I do?

equal and the top slightly narrower. For most prints, the next larger standard-size mat works quite well. For example, an 8-by-10 print mounted and matted to a finished size of 11-by-14 appears well proportioned.

Over the years there has been a debate as to the utility and aesthetics of matted versus borderless photographs. Borderless-print presentation, or *bleed mounting*, has several virtues. It is visually clean and lends an air of expansiveness. Bleed mounting works well with some large landscapes, with graphic, bold composition, and with action/sports photography. Psychologically, it seems to imply informality. If you want the viewer to expand the image beyond its physical boundaries, by all means try a bleed mount. Be careful, though: Not all subjects can survive such treatment. A compromise might be to use a very narrow mat in a neutral color in order to partially limit viewing parameters.

The case for a wide, strong mat is different. Large mats tend to force the eye to the heart of the image, limiting the viewer's perceptual field in much the same way that the camera viewfinder does. If the image contains extensive detail, complex tonal relationships, or strong central content, a wide mat is usually called for.

Mat Color

Black-and-white photographs are usually enhanced by black, white, or off-white mats. But keep in mind that black-and-white printing paper is not all the same. The white base color of paper varies a great deal from cool to warm in tone. Black varies as well, some papers exhibiting decided tints from blue to brown. Choice of mat color depends to an extent on the tint of the black-and-white printing paper used.

For color prints, a wider range of options is available. If you can, try to choose a mat color that closely approximates the dominant hue in the print. Another option is to choose a mat color that matches the hue of an important detail in the print. As a general guideline, avoid bright, warm colors such as red-orange and bright yellow because mats in these colors become strong visual elements themselves and will detract from the visual impact of most images. Gray, brown, tan, beige, muted yellow, green, and blue are the mat colors most often used to advantage with color prints.

Image Placement

Several image-placement variations are possible in addition to the standard format described above. Placing an image to the left of center within the mat can emphasize the size of the subject. Low, heavily top-weighted matting forces the viewer's attention to the image occupying the bottom of the mat. Mounting a photograph to the right of center within the mat also forces attention to the image.

Frames

Some prints may be effectively displayed without frames—for example, moody, low-key prints. But most photographs will benefit from tasteful and intelligent framing. Frames have two functions:

1. They separate an image from its surroundings, drawing attention to the subject matter.

2. They help project the two-dimensional photograph from the wall, commanding the viewer's attention and contributing to the illusion of depth.

David Reasinger

The impact of many photographs can be diminished by indifferent framing or matting. In these examples framing and matting enhance the qualities inherent in the subject matter.

Photographic frames need to be simple, sturdy, and unobtrusive. Some of the more popular types are the plastic box, the metal section, and straight-line wood frames. In addition, there are several "frameless" frame systems, such as Uniframes and Gallery Hooks. The Uniframe is a special favorite of ours, for it is clean, neat, relatively inexpensive, and efficient.

Displaying Prints

Here are some guidelines concerning display:

1. Place large pictures (larger than 8-by-10) so that the middle is just above eye level. Smaller photographs should be positioned at about average eye level, approximately 5 to 5½ feet from the floor.

2. When hanging large photographs, be sure to leave enough viewing distance for the entire image to be seen at one glance.

3. Uniformly painted walls in neutral colors offer the environment most conducive to photo display.

4. Small photographs can be grouped provided the manner of framing is similar. Mixing metal, wood, and/or plastic frames rarely works well visually. Hanging a group of photographs can be a painstaking and sometimes frustrating undertaking, so lay out the grouping on the floor before you begin to hang.

5. Try to select subject matter that blends with the room's decor and/or function.

6. Because photographs are viewed by means of reflected light, they need a bright and even source of illumination. Attractive and important photographs often go unnoticed because of poor lighting. If lighting is a problem, you might consider gallery lights made specifically for illuminating artwork. These are available in art and frame shops.

In summary, keep in mind that all of these guidelines depend upon subject matter and residual message. Let your artistic intuition guide your decisions about matting, framing, and hanging photographs. The following exercise may help sharpen your intuition concerning this vital aspect of seeing.

exercises

1. Gain experience in the craft of display by making up a mood chart. Select ten of your photographs and complete the chart on the facing page for each. We have provided several examples in order to stimulate your imagination.

2. Examine photographs hung in a gallery or musuem. How effective is the overall display. Does the mounting, matting, and framing help you see the images? If not, how would you have presented them?

3. Visit an art shop or do-it-yourself frame store. Examine the framing possibilities and make a list of the potential uses of various frames and mats, matching them to photographs you have already taken or plan to take. Talk with the store personnel.

4. Select one of your prints and make two or three copies. Produce alternative display themes for each. Have several of your classmates or friends critique the finished set of photographs. If you can afford it, repeat with a number of varied subjects.

Photo–Display Mood Chart

Effect/Mood	Subject	Mount/Frame	Hanging Plan
serene	mountain lake 11×14 B/W	narrow gray mat black metal frame	over chair in living room centrally placed on 6-foot wall
action	race car	bleed mounted to board	over couch in family room lower than eye level to emphasize ground-hugging quality

Self-Evaluation and Critique

Eventually those of us who take photography seriously search for a mechanism with which to judge our own work. This task can be difficult and frustrating because quality has a different meaning for each of us. The problem of setting personal standards is compounded by the fact that of all the visual art forms, photography suffers most from the lack of universally accepted criteria. It is incumbent upon each of us to develop a method for making critical judgments about our work. As we evaluate our work we should not merely borrow from traditional art forms but rather develop a set of standards that take into account the unique expressive qualities of photography.

We advocate a developmental model because current photographic criticism

1. Uses nonuniform standards
2. Is inconsistent
3. Has borrowed from other mediums inappropriately

Further, a personal developmental model may be more valuable as a learning tool, for it can be tailored to individual needs far better than any externally imposed model. We feel it will do far more than any external criticism to foster individual growth.

The Aims of the Developmental Model

1. To Generate Questions

The model will help generate questions concerning ability level, intent, execution, and so on. Constant questioning of ourselves and our work can help us generate new ideas and strategies and refine our technique.

2. To Construct Definitions of Success

We can find success on two levels, internal and external. Internal rewards come from positive answers to questions such as "Do I enjoy the *activity* of photography as well as the end product?" and "Am I satisfied with the images I create?" Answering questions such as these can give us insight into how well the medium satisfies our inner needs.

We all need confirmation! Whether we need it with regard to our photography is a question each of us must answer for ourselves. At some point you may wish or need to seek external reinforcement. At that point you will have to decide how much you are willing to risk to get it. Will you be willing to accept the judgment of others? There is a certain seduction in external recognition. You may be surprised to find how important it becomes to you. External evaluation is appealing because of its ostensible objectivity. That is, a thoughtful, constructive, and objective external critical analysis of your work can often redirect your efforts in more productive and fulfilling directions. Sometimes we are just too close to our work to judge it fairly.

3. *To Stress Ongoing Growth*

The most important contribution this or any other evaluative device can make is to point out areas of accomplishment and areas in which we need improvement. The model we offer is intended as a tool for fostering your growth in photography. It is by no means a tool for judging good or bad.

Before turning to the developmental model itself, let's summarize the points made so far:

1. Critique and evaluation are valuable if they teach something that stimulates personal growth.
2. Your judgment is more valuable than anyone else's.
3. Success if to be found on several levels. You must decide where success lies for you.
4. Any model of critique and evaluation is only as good as the questions it raises.

5. Only you can determine the standards you are willing to accept for your work. The question becomes, Whose judgment do you value and in what form?
6. There are no good and bad photographs—just those that make the human connection between photograph and viewer and those that don't.

The Developmental Model*

Visualization Stage

Physical Criteria

1. What techniques are best suited to your purposes?
2. As you look at the scene, what perspective is suggested?
3. Can you choose equipment more suited to your purpose?
4. Can you see physical contrasts? (light/dark, rough/smooth, large/small, etc.)

Qualitative/Intellectual Criteria

1. As you look at the scene, is there an idea or concept in your mind's eye?
2. What feeling do you get from what you see?
3. Do the physical limitations of the camera-lens-film combination change your concept?
4. Can what you feel be translated through photography? (Some feelings just can't.)
5. Can you physically remove anything from the scene?
6. Why is the scene worth photographing?
7. Does the image in your mind suggest color or black and white?

*From Marc B. Levey, *Photography: Composition, Color, Display.* New York: Amphoto, 1979.

Production Stage

Physical Criteria

1. What choices do you have in terms of contrast, paper grade, paper surface, or special techniques?

2. Does the negative/transparency possess physical qualities suggestive of special techniques?

3. How large should the print be? . . .

4. Are there physical defects in the negative or transparency that can't be overcome?

5. Are there new techniques or processes you need to learn?

Qualitative/Intellectual Criteria

1. Does the negative/transparency suggest any new or exciting alternatives? Do you see anything new in the negative?

2. How can the "message" of the photograph be best revealed through darkroom technique?

3. Upon careful examination, is the negative worth printing?

Revisualization Stage

Physical Criteria

1. Does the print meet your technical standards?

2. Are there distracting spots or areas?

3. Could a different perspective enhance the ideas you wished to present?

4. If in color, does the color enhance/support the theme of the image?

5. Does the composition confuse or clarify the communication?

6. How can the print be best matted, framed, and displayed?

Qualitative/Intellectual Criteria

1. Do you find anything new and visually exciting in the finished print? Are you surprised by what you find?

2. Does the picture say what you want it to say?

3. Does the print suggest new avenues for your personal expression?

4. Does the print enhance the environment in which it is displayed?

5. Do you derive personal satisfaction from the photograph?

6. If you redid the image, what would you change? Do you need to know more to make the change effective?

As you can see, the model is divided into the three stages of image creation: visualization, image production, and revisualization. Analysis questions are divided into observable criteria and the not so easily observable qualitative/intellectual criteria. Use the model as an evocative tool and not as a measure of good or bad, right or wrong.

exercises

1. Ask yourself the following questions about the model:

 a. What do the three steps in the photographic process—visualization, production, and revisualization—represent?

 b. What would you delete from or add to the model?

 c. Which questions in the model are immediately relevant to your work?

 d. How could it be reorganized so as to be more useful to you?

2. Choose a print or slide that has special significance for you. Evaluate the image, using the applicable questions from the model. Do you see anything in the image differently? Can you improve it in any way? What role did a systematic evaluation play in making these judgments?

3. Using the model as a starting point, build a personal developmental/analytical model. You may use any part of the model or start from scratch. Make sure you can defend the model you construct.

Bibliography

Aaron Siskind: Places—Photographs 1966–1975. New York: Farrar, Straus & Giroux, Light Gallery, 1976. *(19)*

Adams, Ansel, *The Portfolios of Ansel Adams.* Boston: New York Graphic Society, 1977. *(15)*

Albers, Josef, *Interaction of Color* (2nd ed.). New Haven: Yale University Press, 1983. *(22, 23)*

Andre Kertesz. Aperture History of Photography. Millertown, N.Y.: Aperture, 1977. *(17)*

Arnheim, Rudolph, *Art and Visual Perception* (2nd ed.). Berkeley and Los Angeles: University of California Press, 1969. *(2, 28)*

Arnason, H. A., *History of Modern Art.* Englewood Cliffs, N.J.: Prentice-Hall, 1971. *(19)*

The Art of Photography (rev. ed.). Life Library of Photography. Alexandria, Va.: Time-Life Books, 1981. *(17, 19, 26, 34)*

Bailey, Adrian, and **Adrian Holloway,** *The Book of Color Photography.* New York: Knopf, 1979. *(23, 24)*

Blaker, Alfred A., *Photography: Art and Technique.* San Francisco: W. H. Freeman, 1980. *(14, 15, 16, 19, 30, 31, 33, 35)*

Boyd, Harry, Jr., *A Creative Approach to Controlling Photography.* Austin, Texas: Heidelberg Press, 1974. *(34)*

Brandt, Bill, and **Mark Haworth,** *The Land: Twentieth Century Landscape Photographs.* London: Gordon Fraser Gallery, 1975. *(13)*

Cartier-Bresson, Henri, *The Decisive Moment.* New York: Simon & Schuster, 1952. *(14)*

Clifton, Jack, *The Eye of the Artist.* Westport, Conn.: North Light Publishers, 1973. *(28)*

Coleman, A. D., *Light Readings.* New York: Oxford University Press, 1979. *(14, 15, 16, 36)*

Color (rev. ed.). Life Library of Photography. Alexandria, Va.: Time-Life Books, 1981. *(23, 26)*

Croy, O. R., *The Photographic Portrait.* London: Focal Press, 1968. *(11, 29)*

Italic numbers following bibliographic entries indicate applicable modules.

Craven, George M., *Object and Image* (2nd ed.). Englewood Cliffs, N.J.: Prentice-Hall, 1982. *(15, 16, 19, 21, 30, 31, 35)*

Davis, Phil, *Beyond the Zone System.* Somerville, Mass.: Curtin & London, 1981. *(30)*

Digrappa, Carol, *Fashion: Theory.* New York: Lustrum Press, 1980. *(21)*

Dossett, Royal, *Book X-6.* Excelsior, Minn.: Dossett Publications, 1976. *(35)*

Ducrot, Nicholas, ed., *Andre Kertesz: Sixty Years of Photography.* New York: Viking, 1978. *(17)*

Edward Weston: His Life and Photographs. Millertown, N.Y.: Aperture, 1975. *(15)*

Edward Weston: Nudes. Millertown, N.Y.: Aperture, 1977. *(15)*

Edwards, Betty, *Drawing on the Right Side of the Brain.* Los Angeles: J. P. Tarcher, 1979. *(12)*

Eugene Atget. Aperture History of Photography Series. Millertown, N.Y.: Aperture, 1980. *(13)*

Farber, Paul, *Professional Fashion Photography.* New York: Amphoto, 1979. *(11, 21)*

Feininger, Andreas, *The Color Photo Book.* Englewood Cliffs, N.J.: Prentice-Hall, 1969. *(23)*

————, *The Creative Photographer.* Englewood Cliffs, N.J.: Prentice-Hall, 1955. *(33)*

————, *Principles of Composition.* Englewood Cliffs, N.J.: Prentice-Hall, 1972. *(33)*

Freiden, Wolfgang, *Modern Photographic Techniques.* New York: Crescent Books, 1976. *(29)*

Friedman, Joseph S., *History of Color Photography.* London: Focal Press, 1968. *(26)*

Goldsmith, Arthur, *The Photography Game.* New York: Viking, 1971. *(12, 16, 21)*

The Great Photographers. Life Library of Photography. Alexandria, Va.: Time-Life Books, 1972. *(17)*

Gregory, R. L., *Eye and Brain.* New York: McGraw-Hill, 1967. *(2)*

Haas, Ernst, *The Creation.* New York: Viking, 1971. *(26)*

————, *The Face of Asia.* London: Thames & Hudson, 1972. *(26)*

————, *Himalayan Pilgramage.* New York: Viking, 1978. *(26)*

————, *In America.* New York: Viking, 1975. *(26)*

————, *In Germany.* New York: Viking, 1977. *(26)*

————, *Man and Machine.* New York: IBM World Trade Corp., 1969. *(26)*

————, *To Dream With Open Eyes.* Minneapolis: Media Loft, 1980. *(26)*

Hall, Edward T., *The Hidden Dimension.* New York: Doubleday, 1966. *(4)*

Hattersley, Ralph, *Discover Yourself Through Photography.* Dobbs Ferry, N.Y.: Morgan & Morgan, 1976. *(12, 20)*

Hedgecoe, John, *The Art of Color Photography.* New York: Simon & Schuster, 1978. *(6, 23, 24, 25, 33)*

————, *The Book of Photography.* New York: Knopf, 1976. *(6)*

Henri Cartier-Bresson. Aperture History of Photography Series. Millertown, N.Y.: Aperture, 1976. *(13)*

Isert, I., *The Art of Color Photography.* New York: Van Nostrand Reinhold, 1971. *(25)*

James, Jane H., *Perspective Drawing: A Directed Study.* Englewood Cliffs, N.J.: Prentice-Hall, 1981. *(28)*

Janson, H. W., *History of Art.* Englewood Cliffs, N.J.: Prentice-Hall, 1969. *(19)*

Jerry N. Uelsmann: Silver Meditations. Dobbs Ferry, N.Y.: Morgan & Morgan, 1975. *(19)*

Karsh, Yousef, *Karsh Portfolio.* Toronto: University of Toronto Press, 1967. *(11)*

Kendler, Howard H., *Basic Psychology.* New York: Appleton-Century-Crofts, 1968. *(1)*

Kertesz, Andre, *Distortions.* New York: Knopf, 1976. *(17)*

Kobre, Kenneth, *Photojournalism: The Professional Approach.* Millertown, N.Y.: Aperture, 1980. (7, 8)

Koestler, Arthur, *The Sleepwalkers.* New York: Macmillan, 1959. (12)

Levey, Marc B., *Photography: Composition, Color, Display.* New York: Amphoto, 1979. (25, 35)

———, *The Photography Textbook.* New York: Amphoto, 1980. (2, 5, 7, 30, 31, 32, 36)

Life magazine. Various issues, 1940s–1970s. (16)

Langford, Michael, *The Step-by-Step Guide to Photography.* New York: Knopf, 1978. (17, 19, 21, 26, 29, 30, 31)

Lyons, Nathan, ed., *Photographers on Photography.* Englewood Cliffs, N.J.: Prentice-Hall, 1966. (15, 19)

Maddox, Ben, *Edward Weston: Seventy Photographs.* Millertown, N.Y.: Aperture, 1978. (15, 16)

Malcolm, Janet, *Diana and Nikon.* Boston: David R. Godine, 1980. (24)

Manning, Jack, *The Fine 35mm Portrait.* New York: Amphoto, 1978. (11)

Man Ray Photographs 1920–34 Paris. New York: Random House, 1934. (19)

Mante, Harold, *Photo Design.* New York: Van Nostrand Reinhold, 1972. (22, 23, 32)

Mason, Jerry, ed., *The Family of Children.* New York: Grosset & Dunlap, 1977. (20)

McCullin, Donald, *Is Anyone Taking Notice?* Cambridge, Mass.: M.I.T. Press, 1973. (18)

Meyerwitz, Joel, *Cape Light.* Boston: New York Graphic Society, 1978. (26)

———, *St. Louis and the Arch.* Boston: New York Graphic Society, 1980. (26)

Miller, Jan, *Amphoto Guide to Framing and Matting.* New York: Amphoto, 1980. (35)

Moholy-Nagy, Laszlo, *Vision in Motion.* Chicago: Paul Theobald, 1947. (19)

Murray, Ellwood, Gerald M. Phillips, and J. David Turby, *Speech: Science-Art.* Indianapolis: Bobbs-Merrill, 1969. (3)

Newhall, Beaumont, *History of Photography From 1839 to the Present Day.* New York: Doubleday, 1964. (19, 26)

———, *Photography for the Joy of It.* Toronto: Van Nostrand Reinhold, 1977. (10, 12)

Nibbelick, Don, *Picturing People.* Rochester, N.Y.: Eastman Kodak, 1978. (11)

Patterson, Freeman, *Photography and the Art of Seeing.* Toronto: Van Nostrand Reinhold, 1979. (4, 5, 10, 34)

Penn, Irving, *Moments Preserved.* New York: Simon & Schuster, 1960. (11)

Perry, Robin, *Photography for the Professional.* Waterford, Conn.: Livingston Press, 1976. (21)

Phillips, Gerald M., and J. Jerome Zoltan, *Structuring Speech.* Indianapolis: Bobbs-Merrill, 1976. (18)

Professional Photographic Illustration Techniques. Rochester, N.Y.: Eastman Kodak, 1978. (21)

Porter, Eliot, *Appalachian Wilderness.* New York: Dutton, 1970. (26)

———, *Intimate Landscapes.* New York: Metropolitan Museum of Art, 1979. (26)

Photojournalism. Life Library of Photography. Alexandria, Va.: Time-Life Books, 1971. (16)

Reedy, William A., *Impact.* New York: Amphoto, 1973. (21)

Rubinstein, Eva, *To Explore and Express.* Minneapolis: Media Loft, 1980. (20)

Schottle, Hugo, *Color Photography: The Landscape.* New York: Amphoto, 1978. *(5, 6)*

——, *The Portrait.* New York: Amphoto, 1979. *(11)*

Sheppard, Julian, *Photo Design Methods.* London: Focal Press, 1971. *(32)*

Simmons, Seymour III, and **Marc S. A. Winer,** *Drawing: The Creative Process.* Englewood Cliffs, N.J.: Prentice-Hall, 1977. *(28)*

Smith, W. Eugene, and **Aileen M. Smith,** *Minimata.* New York: Holt, Rinehart & Winston, 1975. *(11, 16)*

Sontag, Susan, *On Photography.* New York: Farrar, Straus & Giroux, 1978. *(15, 19, 24, 36)*

Steichen, Edward, *A Life in Photography.* New York: Doubleday, 1973. *(11)*

Stern, Bert, and **J. Cornfield,** *Photo Illustration.* Los Angeles: Alskog, 1974. *(21)*

Swedlund, Charles, *Photography.* New York: Van Nostrand Reinhold, 1981. *(35)*

Szarkowski, John, *Looking at Photographs.* Boston: New York Graphic Society, 1973. *(13, 19, 36)*

——, ed. *Edward Callahan.* Millertown, N.Y.: Aperture, 1976. *(19)*

Thornton, Gene, *Masters of the Camera.* New York: Harper & Row, 1978. *(8)*

Upton, Barbara, and **John Upton,** *Photography.* Boston: Little, Brown, 1972. *(19, 30, 34, 35)*

Vestel, David, *The Craft of Photography.* New York: Harper Collophon, 1972. *(30)*

W. Eugene Smith: His Portraits and Notes. Millertown, N.Y.: Aperture, 1975. *(16)*

Weston, Edward, *My Camera on Point Lobos.* New York: Da Capo, 1968. *(15)*

White, Minor, Richard Zakia, and **Peter Lorenz,** *The New Zone System Manual.* Dobbs Ferry, N.Y.: Morgan & Morgan, 1976. *(30)*

Wiessenfall, Cheryl, et al., *Women See Women.* New York: Thomas Y. Crowell, 1976. *(20)*

Zakia, Richard, *Perception and Photography.* Rochester, N.Y.: Light Impressions Gallery, 1979. *(1, 2, 4, 9)*

——, and Hollis N. Todd, *Color Primer I and II.* Dobbs Ferry, N.Y.: Morgan & Morgan, 1974. *(22, 23, 25)*